IMAGES
of America

RALEIGH'S
REYNOLDS COLISEUM

Craig Chappelow

ARCADIA
PUBLISHING

Published by Arcadia Publishing
Charleston, South Carolina

Printed in the United States of America

Library of Congress Catalog Card Number: 2002105547

For all general information contact Arcadia Publishing at:
Telephone 843-853-2070
Fax 843-853-0044
E-mail sales@arcadiapublishing.com
For customer service and orders:
Toll-Free 1-888-313-2665

Visit us on the Internet at www.arcadiapublishing.com

CONTENTS

ACKNOWLEDGMENTS

Many people contributed to the completion of this book. Without their help, it would have been impossible to assemble this wide variety of photographs, documents, and narrative about Reynolds Coliseum. Thanks first to Hermann Trojanowski and his current and former coworkers at the North Carolina State University Special Collections Department: Maurice Toler, Russell Koonts, and Reed Underhill. Many gifted photographers contributed their work, including Roger Winstead, Burnie Batchelor, and staff photographers from the North Carolina State University student publications—*The Technician* and *Agromeck*. Thanks to Jim Rosenberg and Richie Zweigenhaft for their editorial help. For assistance locating and securing specific photographs, thanks to Peggy Neal of *The Raleigh News and Observer*, Marcus Green of the *Greensboro News and Record*, and Joe Grabenstein from the LaSalle University Archives. Others who contributed materials from their personal collections include Karl Larson and Ken Blackburn. The images in this book that do not have a credit line following the caption are from my own collection. Thanks to Becky King and Alan Welch for your help. To my family, Sara, Thomas, Benjamin, and Andrew, a special thank you for your support of my work on this project.

One of the most enjoyable aspects of working on this book was the opportunity to interview the many people who readily offered their unique first-hand knowledge about Reynolds Coliseum, particularly William Friday, Irwin Smallwood, Vic Bubas, Bob Yoder, Carter Cheves, C.A. Dillon, Bruce Hatcher, Henry Bowers, and Frank Weedon. I interviewed three additional people who shaped much of my understanding about Reynolds Coliseum. Sadly, they passed away without seeing the final product. This book is dedicated to their memory.

Carl "Butter" Anderson
Willis Casey
Horace "Bones" McKinney

INTRODUCTION

We have become a bit jaded. These days, universities regularly build giant arenas to accommodate their multi-million dollar athletic programs. Seemingly at the drop of a hat, a city will rush to construct a big stadium to attract or retain a professional sports team. Advanced construction techniques and materials are available to erect domes and retractable roofs while corporate sponsors wait in the wings to pay for naming rights to the buildings before the paint dries. Seen through this 21st-century perspective, why create an entire book about an old gymnasium?

To really understand the impact that William Neal Reynolds Coliseum had on North Carolina State University (NC State), Raleigh, and the state of North Carolina, one must be able to view things in 1940s terms. University officials made a risky and bold proposal for the construction of this giant arena—not for sports, but for agricultural shows, cultural events, and military drills. Consider this: In 1940, not only could NC State's entire student body of 2,530 fit inside the proposed coliseum with room to spare, you could fit everyone who ever graduated from NC State in the building with them—and still have 2,000 seats left over. When opened in 1949, the giant brick building seated 12,000 and was the largest indoor facility between Atlantic City and New Orleans.

It was a considerable feat that Reynolds Coliseum was approved, funded, and started, all with the looming specter of United States involvement in World War II. Few people imagined that it would take another nine years before the building would be finished. Certainly, no one anticipated the impact that a fast-talking, gum-chewing basketball coach from Indiana named Everett Case would have by bringing big-time basketball to Raleigh.

Reynolds Coliseum was the kind of place where you did not know what to expect next. Take, for example, what happened in 1951, when Reynolds hosted the NCAA basketball tournament East Regionals. The North Carolina State fans and alumni selected that moment to show Coach Case and Assistant Coach Butter Anderson their appreciation for their coaching success. After NC State finished playing their game, and before the next game of the tournament started, the coaches were called to mid-court to receive an award. Anderson remembers, "The visiting team that was warming up for the next game on one end of the court had to interrupt their warm-ups to make way for two brand new cars that were driven right out to mid-court and presented to us. They gave Everett a Cadillac and gave me an Olds 98. In the meantime, standing over on the sidelines cooling their heels was the team that was going to play in the next game—old Adolph Rupp's Kentucky Wildcats. After the game, Rupp complained to Everett that the ungrateful

alumni at Kentucky had never given him a car. I remember Everett smiled at that and suggested Rupp might want to read *How To Win Friends and Influence People*." Even though NC State lost their game that evening against Illinois, and Kentucky went on to win theirs, Rupp knew, for that moment at least, he had been one-upped by his old nemesis.

The story could end there, with the many personal anecdotes from Reynolds Coliseum as a basketball hotbed in the early heyday of the college sport. After all, over eight million people watched men's basketball games in Reynolds. Some of the best players to lace up their high-tops made their way in to the record books in this building, and many Hall of Fame coaches have prowled the sidelines mere inches from the first row of fans. Yet some of the most memorable stories about Reynolds Coliseum are the ones people tell about the silence. When 12,000 people become instantly quiet, so quiet that you hear someone clear their throat from the other side of the vast arena, you know that what happens next could change the way you see the world. Reynolds has had more than its share of these moments—and surprisingly, some of them had nothing to do with basketball. The goal of this book is to take the reader back in time to better understand the unique origins of Reynolds Coliseum and the lasting impact it has had on the region. Instead of focusing on game scores and statistics, this book attempts to bring the building to life by telling the story of its origins and early history. Come on in and find your seat.

One

FARMERS AND
MECHANICS

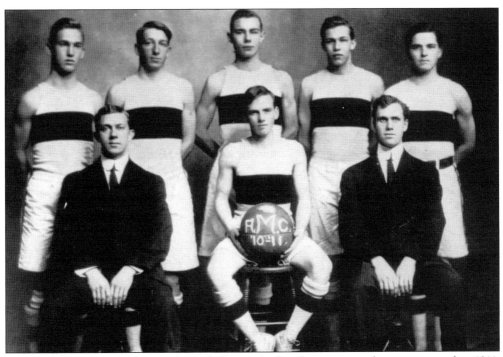

The first North Carolina A&M basketball team had no home court when it organized in 1911. The "Farmers" had to practice on an outdoor field known as the Red Diamond, located where Pullen Park currently stands. Team members (not listed in photo order) included Percy Ferebee of Elizabeth City, John Bradfield of Charlotte, Frank Crowell of Concord, Davis Robertson of Portsmouth, Virginia, J.C. Small of Elizabeth City, Harry Hartsell of Asheville, Henry Harrison of Enfield, and J.R. Mullen of Charlotte. (Courtesy of NCSU Libraries' Special Collections.)

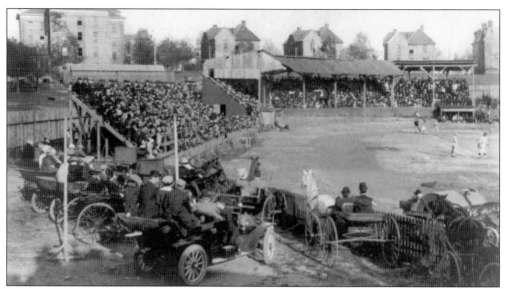

Football and baseball were already established on campus and this athletic field (later known as Riddick Field) was used for both sports. This 1910 photo shows spectators watching a baseball game. The people in the bottom right corner might be participating in the first-ever tailgate party. (Courtesy of NCSU Libraries' Special Collections.)

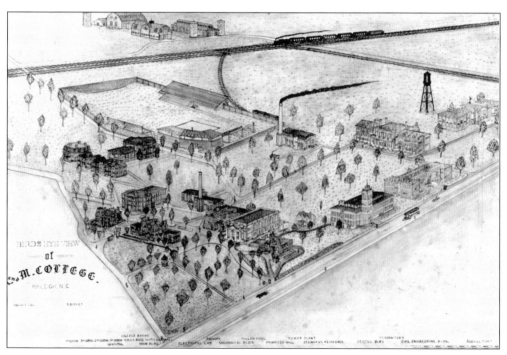

This campus map, created in 1911, shows the college grounds as they looked when basketball began and illustrates the dual football and baseball layout on Riddick Field. The campus is bordered by Hillsborough Street at the bottom right. Pullen Hall is in the foreground with the pillared entrance. Reynolds Coliseum would be constructed 30 years later across the railroad tracks on the site of the college farm and orchard. (Courtesy of NCSU Libraries' Special Collections.)

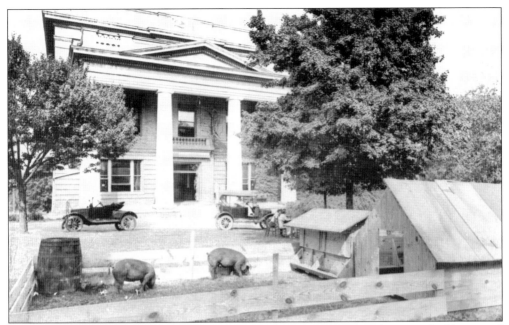

Pullen Hall served as the college's first basketball home. In addition to housing the library and dining room, there was an upper-level assembly hall that could be cleared for larger events, including the new hoop sport. This August 28, 1919 photo was snapped during the annual Farm and Home Week and shows a swine exhibit set up in front of the building. The exhibitors have a table set up in the shade of the large tree. (Courtesy of NCSU Libraries' Special Collections.)

On February 21, 1911, the Farmers cleared the floor in this assembly hall and played against Wake Forest in Raleigh's first college basketball game. The playing floor, polished for a German Club dance the night before, was too slick for players from either team to get traction. At halftime, an enterprising professor brought the Farmers a bucket of kerosene in which they soaked the rubber soles of their shoes. The improved grip led to a 19-18 victory for the Farmers. (Courtesy of NCSU Libraries' Special Collections.)

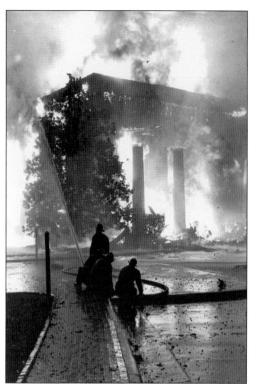

In February 1965, a fire broke out in Pullen Hall. Although Pullen Hall and much of its contents were lost, firefighters worked through the night to prevent the blaze from spreading to other nearby buildings. (Courtesy of NCSU Libraries' Special Collections.)

Students view the ruins on the morning after the Pullen Hall fire. All that remained of the building was the brick shell and front pillars, the building's signature element. Investigators later determined that the fire was set by a student arsonist. (Courtesy of NCSU Libraries' Special Collections.)

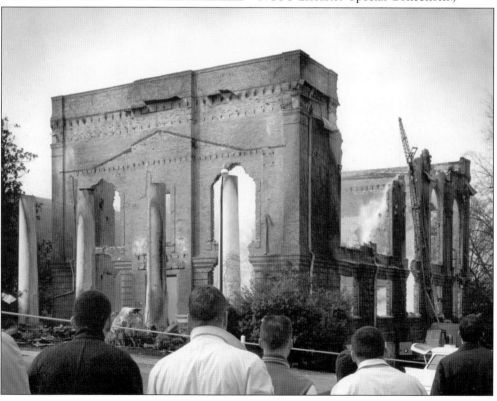

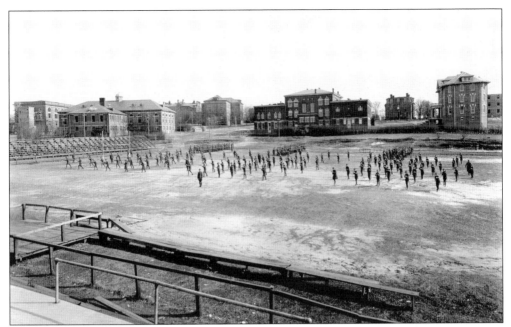

Initially, all students were required to participate in the military program at the college. Members of the college's 2nd Battalion are shown holding bayonet practice in this *c.* 1920 photo. On and off through the years they were required to participate in drills and dress parades, most of which were conducted on Riddick Field and open to the Raleigh public to watch. (Courtesy of NCSU Libraries' Special Collections.)

Starting in the mid-1920s, military training focused more on classroom teaching and less on physical training. College officials believed that students needed exercise and they instituted a physical education program. This 1926 photo shows an exercise class on Riddick Field. Notice the workout attire varies from overalls to what appears to be a bathing suit on the person in the lower right corner. (Courtesy of NCSU Libraries' Special Collections.)

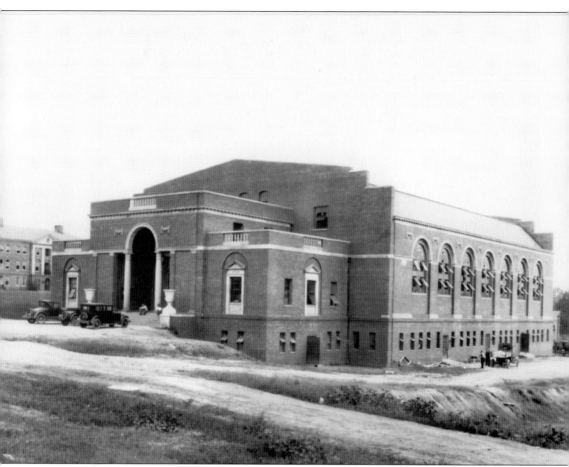

Built in the fall of 1924 for $216,000, Frank Thompson Gymnasium was considered state of the art. It featured an elegant, classical-revival–style front foyer, showers, locker rooms, and an indoor swimming pool. It was designed to be a part of a complete education for the all-male student body of 1,200 enrolled at the time of its construction. Thompson Gym made it possible for NC State to be the first college to introduce a physical education course that carried college credit. It would also serve as the first permanent home for the NC State College basketball team—now known as the "Red Terrors" for their bright red uniforms. (Courtesy of NCSU Libraries' Special Collections.)

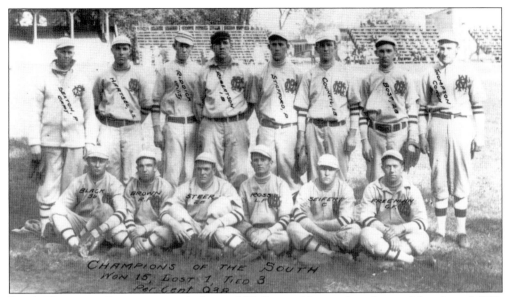

Frank Thompson Gym was named after an NC State athlete and graduate of the class of 1909. Thompson was captain of the baseball and football teams as a student, and returned to NC State as the baseball coach. In 1917, well beyond draft age, Thompson enlisted in the army and was killed in combat in Europe in World War I. (*Agromeck* photo.)

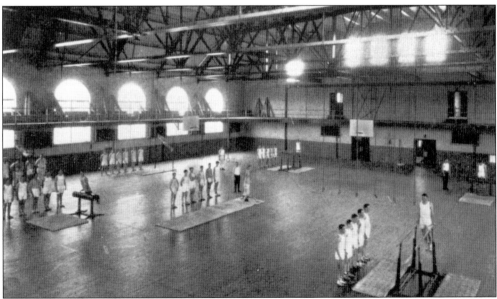

This interior photo of Thompson Gymnasium shows a physical education class in progress. Note the elevated running track. A 1924 issue of the student newspaper, *The Technician*, said that the gym contained, among other features, "a footprint machine used for the showing of the degree of flatness of the foot and a silhouetegraph, which is a camera designed for taking silhouettes and showing postural defects. This apparatus will be use extensively in corrective work among the students." (Courtesy of NCSU Libraries' Special Collections.)

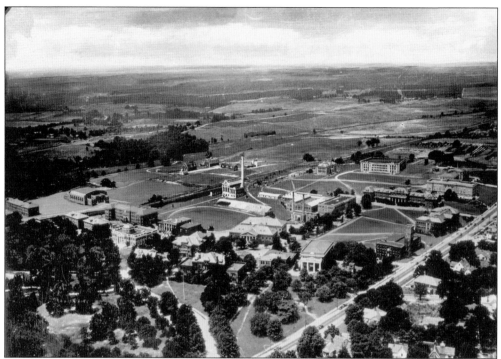

In this 1925 aerial photo, newly completed Thompson Gym is visible in the center, left. Built as a multi-use facility, Thompson was not ideal for basketball. The running track in the balcony extended out over the corners of the court. When a visiting team's player set up to shoot from the deep corners, NC State players would sag back, knowing that the balcony had a better shotblocking percentage than they did. (Courtesy of NCSU Libraries' Special Collections.)

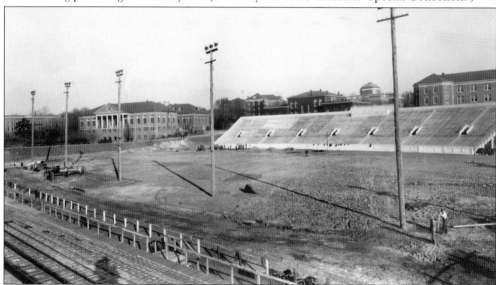

NC State College continued to upgrade athletic facilities through the 1930s. As a part of the federal "New Deal" program, Riddick Stadium received an overhaul that included the construction of permanent bleachers, a field house, and lights. Note the narrow spacing of the seat numbers in the lower left corner. (National Archives photo.)

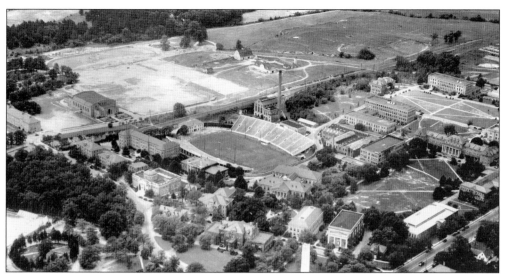

Improvements to Riddick Stadium, including the new field house on the left edge of the field, are seen in this 1938 aerial photo of campus. (Courtesy of NCSU Libraries' Special Collections.)

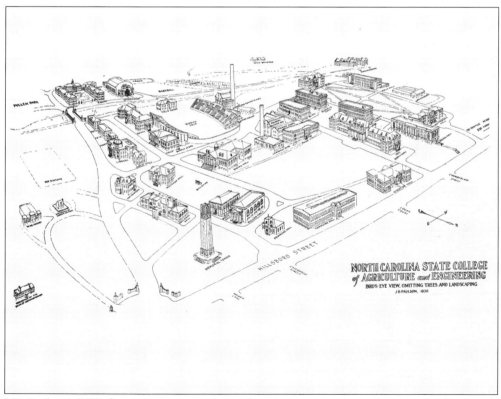

J.D. Paulson's 1939 drawing of campus shows the same perspective as the previous photo with buildings labeled and without trees. (Courtesy of NCSU Libraries' Special Collections.)

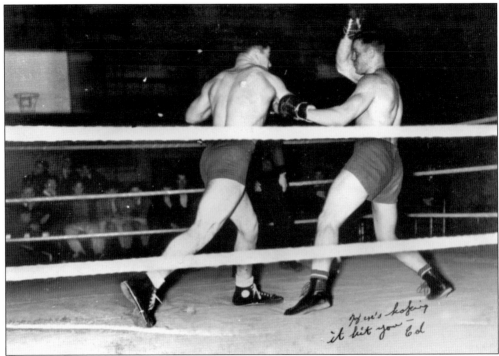

Thompson Gym lived up to its reputation as a multi-purpose facility. In this 1937 photo, Ed "Ty" Coon (left) and Andy Pavlovsky square off in a boxing match. The photo is signed "Here's hoping it hit you . . . Ed." (Courtesy of NCSU Libraries' Special Collections.)

Thompson Gym served as a meeting space and an exhibit area for a variety of events, including the annual Farm and Home Week. In this August 1946 photo, two men inspect a display about new ventilation and irrigation techniques. (Courtesy of NCSU Libraries' Special Collections.)

18

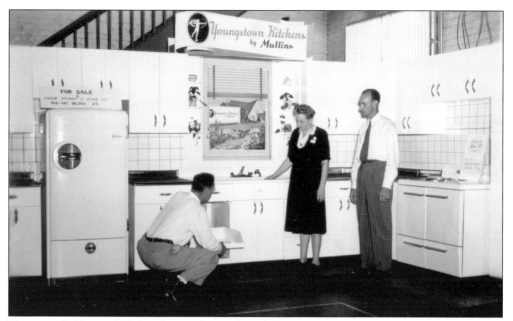

Farm and Home Week always featured exhibits and demonstrations of interest for women as well. This exhibit features an ultra-modern kitchen. (Courtesy of NCSU Libraries' Special Collections.)

In 1933, NC State College and Raleigh officials successfully negotiated for the Southern Conference tournament to be played in Raleigh's Memorial Auditorium. Before that time, the tournament was held in Atlanta. This photo shows game action in the 1939 tournament. A court was set up in the orchestra area of the auditorium, and fans seated on the stage are visible in the background. (Courtesy of NCSU Libraries' Special Collections.)

In 1940, Horace "Bones" McKinney enrolled as a 6-foot-6-inch, 170-pound freshman. McKinney was as well known for his on-court clowning antics as well as his considerable basketball skills. After leading the Southern Conference in scoring his sophomore year, he left school to join the service in 1942. After his service duties ended, he transferred to the University of North Carolina and played on the Carolina team that reached the 1946 national finals. (*Agromeck* photo.)

Bones McKinney played six years in the NBA with the Boston Celtics and Washington Capitals. He returned to the state of North Carolina as the assistant coach at Wake Forest under Murray Greason. McKinney is shown here (crouching) in a game at Reynolds Coliseum in 1953. He was head coach of the Deacons from 1958 to 1965 and won two conference championships, a Dixie Classic title, and took his team to the Final Four in 1962. (Courtesy of *The Raleigh News and Observer*.)

Although the building carries the name of Reynolds, its origins belong to David Clark. As an engineering student, Clark played on NC State baseball and football teams, and served in the Spanish-American War. By the age of 21, he was a veteran and had earned four college degrees. A successful textile industrialist and publisher, Clark aggressively supported the civic, political, and religious organizations in which he was involved, but none as fervently as NC State athletics. (Courtesy of NCSU Libraries' Special Collections.)

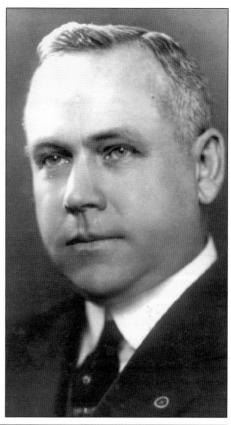

Clark, shown in his office, is reported to have said, "NC State College needs an indoor stadium where rain or shine 10,000 farmers can get together to solve their problems, a building big enough to accommodate all kinds of agricultural exhibits, farm demonstrations, machinery displays, industrial exhibits, an armory for the ROTC, an auditorium for religious meetings, opera, symphony concerts, and an arena for horse shows, cattle shows, and sports events." Controller W.D. Carmichael of the Consolidated University agreed in principle to the need for such a facility, and the seed for Reynolds Coliseum was planted. (Courtesy of NCSU Libraries' Special Collections.)

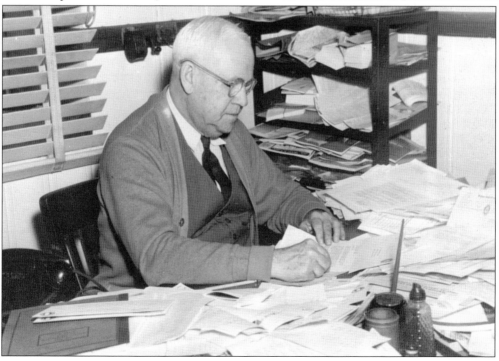

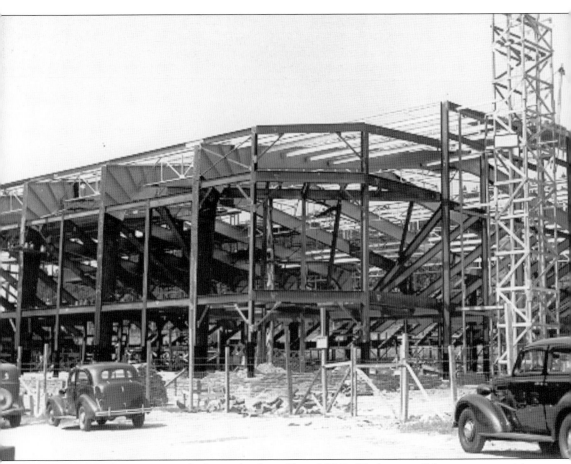

Buoyed by his success with Carmichael in Chapel Hill, Clark was off for one more visit to a neighboring university. The building committee at NC State decided that they would do well to follow the same building plan used for the recently completed indoor stadium at Duke University, shown here under construction in 1939. A.C. Lee of the Lee Construction Co. was the structural engineer for Duke's facility, and NC State wasted no time in enlisting his services to construct a similar building on their campus in Raleigh. With Duke's cooperation, designers used the blueprints from the indoor stadium and saved $15,000 in design fees. Not satisfied to merely copy the design of the Duke building, NC State officials took Lee aside and instructed him to add 26 feet to the length of the building—making it slightly larger than the Duke facility. (Courtesy of *The Raleigh News and Observer.*)

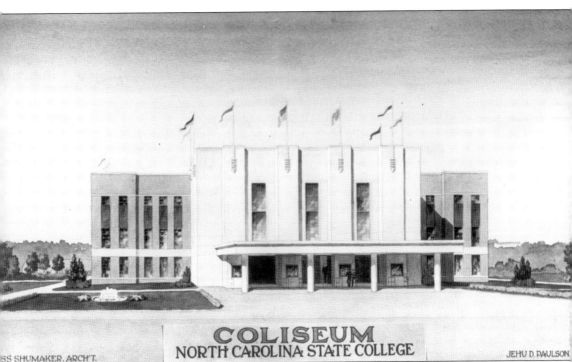

COLISEUM
NORTH CAROLINA STATE COLLEGE

SS SHUMAKER, ARCH'T. JEHU D. PAULSON

With this start in 1940, NC State officials enlisted the help of Ross Shumaker, a professor in the school of architecture. Shumaker, with the assistance of architecture students, worked from the Duke floor plan to create their design and decide on the building's general appearance. It would be constructed of red brick and limestone that was characteristic to the Raleigh campus, rectangular and constructed in an architectural style called "modern classic." Shumaker and students built a four-foot-long scale model of the coliseum. The only remaining question was how to pay for the estimated building cost of $300,000. (Courtesy of NCSU Libraries' Special Collections.)

Carmichael packed up the model and traveled to Greenwich, Connecticut to enlist the interest and, more importantly, the financial help of Mary Reynolds Babcock and her husband, Charles Babcock. Mary was the daughter of tobacco magnate R.J. Reynolds, Charles was a successful stockbroker, and both were known to be generous philanthropists. After presenting the plans for the arena to Mrs. Babcock, Carmichael left the model at their home so that Mrs. Babcock would see it every time she passed through her living room. (Courtesy of Reynolda House, Museum of American Art.)

Several weeks after his visit, Carmichael received a telegram from the Babcocks that read "Letter in mail to you this morning. Believe you will consider it favorable. Suggest you come to NY early next week." The Babcocks agreed to donate $100,000, approximately one-third of the cost for the building. This snapshot of Mrs. Babcock was taken Easter 1941. Charles Babcock carried this photo in his wallet while serving in Europe during World War II. (Courtesy of Reynolda House, Museum of American Art.)

Mrs. Babcock suggested that the building bear the name of William Neal Reynolds, and NC State officials readily agreed. Mr. Reynolds had been one of the owners of the Reynolds Tobacco Co. since 1881. He was an industrial leader, a philanthropist, and most importantly, he was Mrs. Babcock's uncle. (Courtesy of NCSU Libraries' Special Collections.)

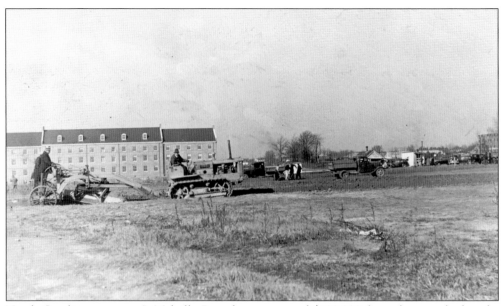

North Carolina governor J. Melville Broughton approved $100,000 from the state budget for the coliseum project, and, since the building would be the home for the ROTC classes, the federal Works Progress Administration agreed to supply $99,999. In this photo, construction equipment breaks ground for Reynolds Coliseum in the fall of 1941. Little did they know that from this day it would take more than eight years to finish the building. (Courtesy of NCSU Libraries' Special Collections.)

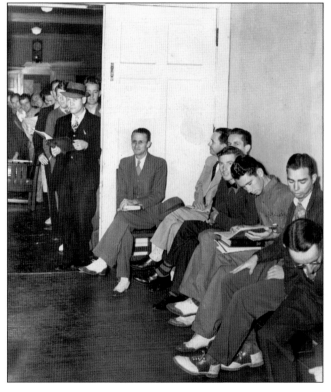

Faculty members and students are lined up for Selective Service registration on campus. In June 1941, Governor Broughton announced that the purpose for the planned coliseum was, "Primarily an armory and a national defense project, providing ample space for indoor instruction of military science and tactics for the NC State College ROTC unit, the building will have 'total defense' significance." The building was designed to include space for the 1,600 ROTC students to drill, a rifle range, 18 ROTC classrooms, offices, and a library. (Courtesy of NCSU Libraries' Special Collections.)

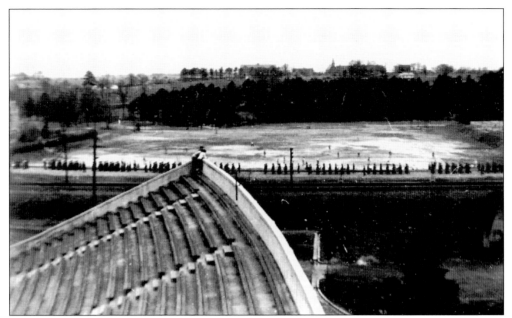

Onlookers watch from the top of Riddick Stadium as members of an Army Specialized Training Program march to class in 1943. With the country now at war, construction on Reynolds came to a halt. Its foundation was already being taken over by the grass and drifting sandy soil. Nearby, a half-million bricks waited, their neat stacks already covered by weeds. The first inhabitants of Reynolds were not military training officers or athletes, but birds and rabbits. (Courtesy of NCSU Libraries' Special Collections.)

Suddenly structural steel was in great need for defense uses. At first, NC State business director J.G. Vann (pictured) and Controller W.D. Carmichael made several trips to the War Production Board in Washington, D.C. to plead their case for permission to continue the construction of Reynolds. It became apparent that even if the steel were delivered, there would be problems getting the other materials needed to build the giant coliseum. (Courtesy of NCSU Libraries' Special Collections.)

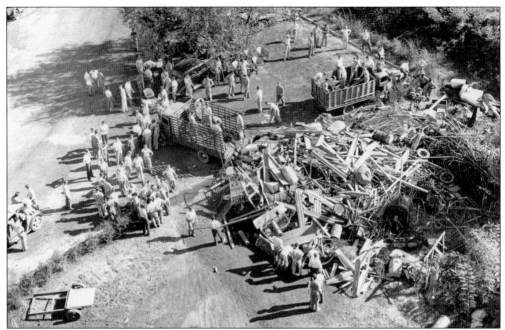

Enrollment at NC State dropped from 2,500 in the autumn of 1942 to only 700 in 1945. Many aspects of student life focused on the war effort. In October 1942, students organized a scrap metal drive, which netted this pile in less than four hours. Rather than push for the steel for Reynolds during a time of national sacrifice, NC State officials decided to wait until the war situation eased. (Courtesy of NCSU Libraries' Special Collections.)

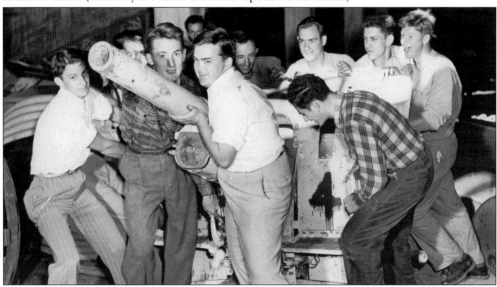

These exuberant students wrangle an antiquated German field artillery piece from beneath the bleachers at Riddick Stadium to throw on the scrap metal pile. Elsewhere on campus, the textile school searched for a substitute for silk to use in parachute construction, the ceramic engineering department designed insulation for radar equipment, and the school of agriculture contributed to the doubling of agricultural output that took place in North Carolina during the war years. (Courtesy of NCSU Libraries' Special Collections.)

NC State officials resigned themselves to the fact that the coliseum would not be available any time soon for large events like the senior exercises shown here. Surprisingly, in the spring of 1943, the Ingalls Iron Works in Birmingham notified NC State that they would fabricate and ship the steel to Raleigh that summer. The steel arrived, almost 1,000 tons of it, over a period of several weeks in June. By the time these materials arrived, the foundation of Reynolds was already two years old. (*Agromeck* photo.)

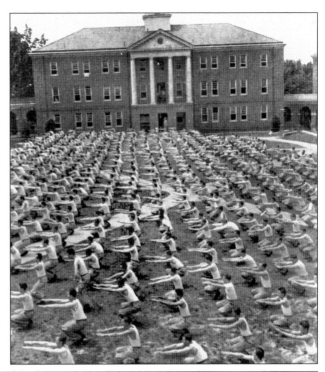

At the time of the Reynolds steel delivery in 1943, NC State had coincidentally begun construction on the Diesel Engineering Building (now a part of Broughton Hall). Since this building was being constructed for military research and training, it had the government's highest priority rating for completion. NC State officials took advantage of the opportunity and used the same crew and equipment to erect the framework of Reynolds. (Courtesy of NCSU Libraries' Special Collections.)

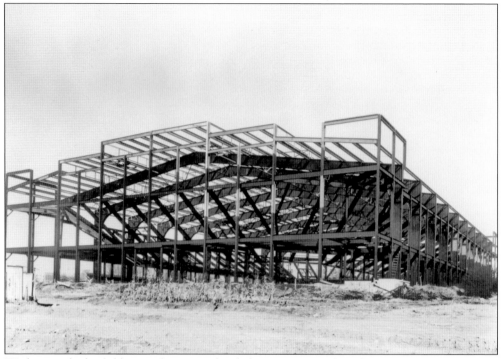

Workers applied a field coat of paint to the skeleton of Reynolds Coliseum to protect it during the wait that was to continue during the war. Getting the steel off the ground probably saved the huge steel beams from being scrapped and redirected to the war effort. Notice the row of corn growing in the foreground. (Courtesy of NCSU Libraries' Special Collections.)

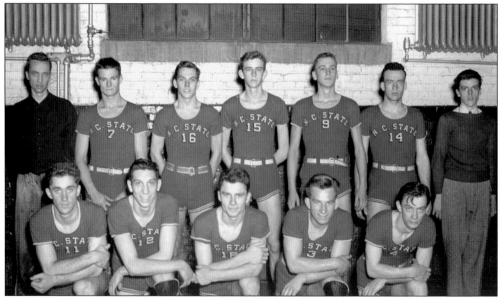

College sports programs either slowed greatly or dropped completely, as athletes and coaches left to join the war effort. The Red Terrors continued to field a basketball team during the war, but they played an abbreviated schedule, and many games were played against military teams. This photo shows the 1944–1945 team, under coach Leroy Jay. (*Agromeck* photo.)

Two

EVERETT CASE

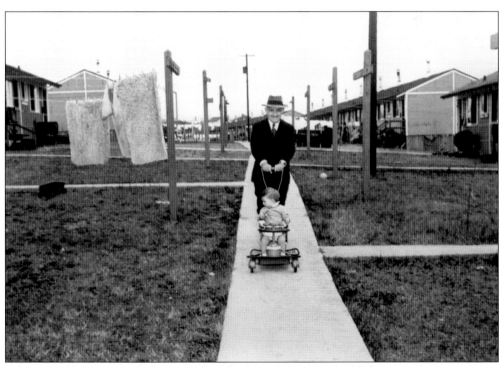

When World War II ended, the student body at NC State doubled in size from its prewar enrollment, largely due to veterans taking advantage of the GI Bill. Returning vets, many of them married, had to be housed. In this photo, Frank Porter Graham, president of the Consolidated University, pushes a baby stroller down the sidewalk of Vetville, a combination of former military barracks and prefabricated housing assembled to accommodate the returning servicemen and their families. More than 1,400 students lived in temporary housing after World War II. (Courtesy of NCSU Libraries' Special Collections.)

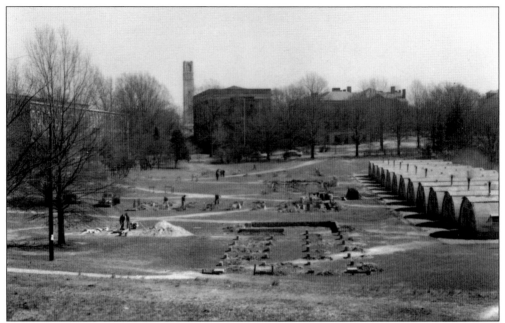

Army surplus Quonset huts served as much needed classroom space. In this February 1947 photo the foundation footings for prefabricated classrooms are visible in the center of the field. (Courtesy of NCSU Libraries' Special Collections.)

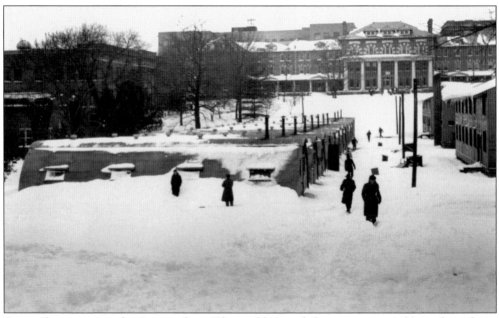

Snow piles up against the Quonset huts. The prefabricated classrooms are visible to the right in this photo. Across campus, the framework of Reynolds Coliseum served as a skeletal backdrop for the 800 students living in trailers wheeled onto the adjacent athletic field. (Courtesy of NCSU Libraries' Special Collections.)

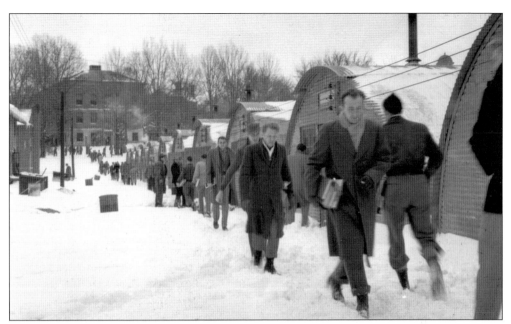

Students walk to class through the snow in February 1948. The uninsulated Quonset hut classrooms were cold and drafty. (Courtesy of NCSU Libraries' Special Collections.)

In 1921, an anonymous letter writer labeled the football team a "wolfpack," referring to their unsavory reputation. The students found the article funny, and the name stuck. Even though Chancellor J.W. Harrelson conducted a contest to select a new mascot, the students persevered in retaining the name Wolfpack. In 1947, all sports teams adopted this nickname. This c. 1950 photo is of one of the early mascots. (*The Technician* photo.)

In 1946, Chancellor Harrelson and Dr. H.A. Fisher, chairman of the athletics council, set out to rebuild the post-war athletic teams. Their first effort was to set up athletic scholarships, and their second effort was to replace the interim war-period coaching staff. David Clark suggested to the Athletics Council, "I am very much in favor of obtaining a good basketball coach and I think that it would probably be useful to look for one in Indiana." Harrelson met with Indiana native Chuck Taylor who happened to be in town with his army team to play NC State. Taylor, (now known for designing and promoting the basketball shoes for Converse Rubber Co.) had another connection with NC State. He held a public demonstration of the young game in Raleigh in 1922. It was the world's first basketball clinic. When Harrelson asked Taylor for his advice on finding a new coach, he knew just the guy. As an Indiana high school senior, Taylor had played for a man named Everett N. Case, pictured here. (Courtesy of NCSU Libraries' Special Collections.)

34

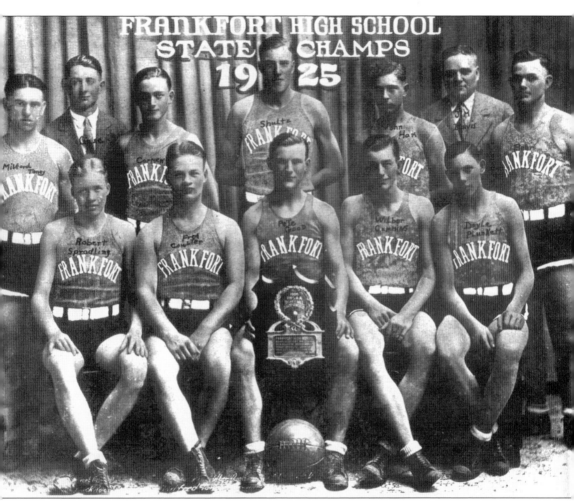

During his high school coaching career, Case compiled an impressive 465-144 record. While at Frankfort High School, Case won the first of four Indiana High School championships when he was just 24 years old with this team. Case is in the back row, second from left. His teams were known and feared by every team in the state. In 1931, Case left Frankfort for the head coaching job at his alma mater, Anderson High School. The importance of high school basketball in Indiana then, as now, cannot be overstated. This was reflected in the number of towns that were building huge gymnasiums during that predepression period. Anderson built a gym in that seated over 5,000 fans. This building, known as the Wigwam, burned down in 1958, and was replaced by a new building that seated 9,000 people. (To this day, 15 of the 16 largest high school gyms in America are in Indiana.) It was no wonder that Case was attracted to the prospect of coaching in giant Reynolds Coliseum. Case was commissioned in the Navy in 1942, where he continued to build winning basketball teams in the service. (*Frankfort Times* photo.)

May 12, 1972

Dear Dr. Fountain:

Everett Norris Case received a master's degree in 1934 from the USC School of Education for his thesis, "An analysis of the effects of various factors on accuracy of shooting free throws in basketball." Our alumni files show that he previously attended the University of Wisconsin, University of Illinois, and University of Iowa, but we have no record of any degrees he might have received at those institutions. I suggest that you write those universities to obtain his records there.

Sincerely

Willis S. Duniway
Director, News Bureau

Dr. Alvin M. Fountain
Box 5434
North Carolina State University
Raleigh, N.C. 27607

WSD:ac

Case left Indiana briefly to become assistant coach at the University of Southern California (USC) under Sam Barry. While at USC, Case took the opportunity to study every aspect of the game. He was a lifelong student—a pure technician of basketball. Case finished his master's degree in English while there. His thesis was an 89-page treatise entitled "An Analysis of the Effects of Various Factors on Accuracy of Shooting Free Throws." His conclusion: the underhand shot is the most accurate. (Courtesy of NCSU Libraries' Special Collections.)

Harrelson offered the NC State coaching job to Case in 1946, and without seeing the Raleigh campus (or the "almost finished" Reynolds Coliseum), Case accepted. Case brought Indiana native Carl "Buttercup" Anderson (in photo) with him as his assistant coach. Butter, as he was known, was a standout 6-foot-two-inch, 260-pound athlete in football and basketball, and had known Case for much of his life. (Courtesy of NCSU Libraries' Special Collections.)

Even though he had received other college coaching offers, Case was attracted to the Raleigh job because he thought that Reynolds Coliseum could be used to bring big-time college basketball to a new part of the country. He was disappointed to discover, upon his arrival, that there were no firm plans in place to finish the coliseum. The fan in this photo is about seven years early for tip-off. (Courtesy of NCSU Libraries' Special Collections.)

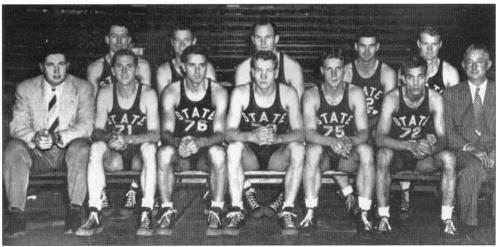

It surprised Case that North Carolina colleges did not schedule basketball games until after Christmas. In order to find some competition before the holidays, he took his 1946–1947 Red Terrors on a tour of the East and Midwest. He returned to Raleigh as a conquering hero. The team won all six of its games on the tour, including a 58-42 victory over a Holy Cross team that featured a player named Bob Cousey and would go on to win the NCAA championship. (*Agromeck* photo.)

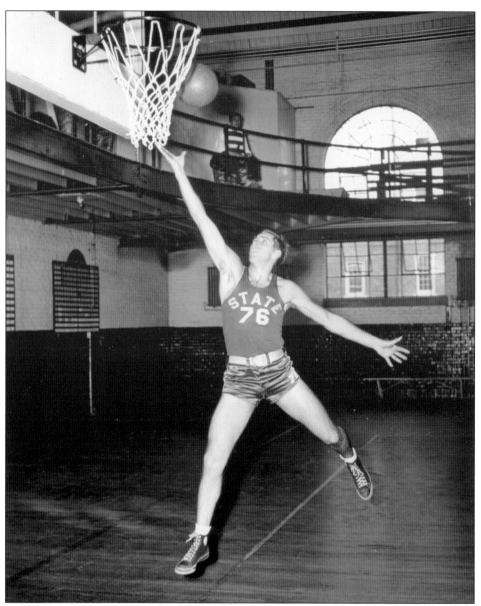

Case had not promised anyone immediate results in his first season, but he did promise exciting basketball. His boys were going to run and gun and press on defense—a style unheard of in the slow, deliberate world of Southern basketball. He recruited most of the players from his native Indiana, and fielded a team consisting of nine freshmen and one junior, the lone returning player that year was Leo Katkavek (in photo). The talent of Case's recruits was so great that the previous year's leading scorer did not make the team. The Raleigh press dubbed the team the "Hoosier Hotshots." They had an average height of six-foot-two, the tallest team NC State ever fielded, and included future NC State coach Norm Sloan. With a few games remaining in the 1946–1947 season, Case's team was 21-4. Fans, hungry from the lean basketball years of World War II, were having a feeding frenzy on the team's success. Despite the attention that Case's teams were attracting, no one could have predicted what was to occur on a cold February evening in 1947. (Courtesy of NCSU Libraries' Special Collections.)

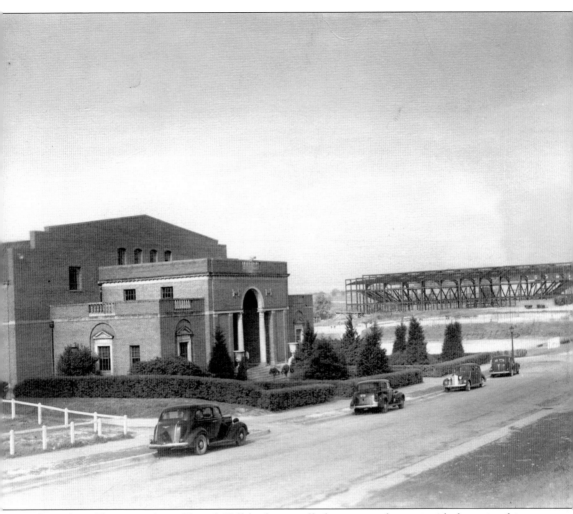

The White Phantoms from Chapel Hill had gone all the way to the national championship game in 1946, the season before Case's arrival, and many of the players from that team were back. They were caught off guard when Case came to Chapel Hill in 1947 and introduced himself to them with a 48-46 overtime victory. Beginner's luck, the Carolina faithful insisted, and the anticipation for the rematch in Raleigh mounted. When the doors opened in Thompson Gym on February 25, 1947 for the NC State-Carolina game, over 4,000 students and townspeople flooded into the building. By 6:30 p.m. every inch of space was occupied by fans standing in the aisles, hanging from the balcony, sitting on railings, even perched in rafters. Tipoff was still an hour away. Fire Chief W.R. Butts arrived at Thompson Gym and calmly asked fans to leave until they had a safe number of people in the building. Suddenly, the doors were torn down by the mob outside, many of whom held legitimate tickets to the game, and hundreds more people streamed in to the building. Chief Butts cancelled the game and ordered the building cleared. He was nearly mobbed by the crowd as he left. (Courtesy of NCSU Libraries' Special Collections.)

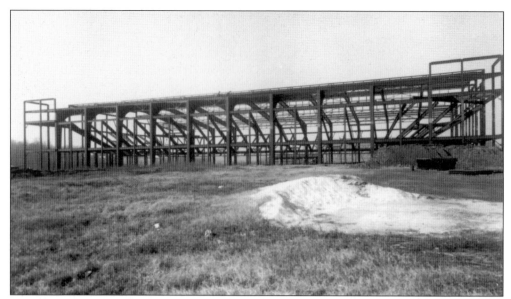

Everett Case was angry. Not one brick had been added to Reynolds Coliseum since his arrival in Raleigh. Grass was growing up through the foundation, exposed metal was rusting, and it could not possibly be ready for even the next year's season. Case hoped that there might have been an influential alumnus or legislator among the crowd that was denied access to the NC State-Carolina game. Perhaps that would jar the lethargic bureaucrats into action to complete the building. (Courtesy of NCSU Libraries' Special Collections.)

By the summer of 1947, Case was skeptical that Reynolds would ever be completed. His 1947–1948 team had to face up to the reality of playing in Thompson Gymnasium for the foreseeable future. Case divided the home games in half for the upcoming season, and distributed tickets so that a given student would have a ticket for only half of the home games. In theory, this would reduce the demand on the building and prevent the kind of catastrophe that occurred last season against UNC. (*Agromeck* photo.)

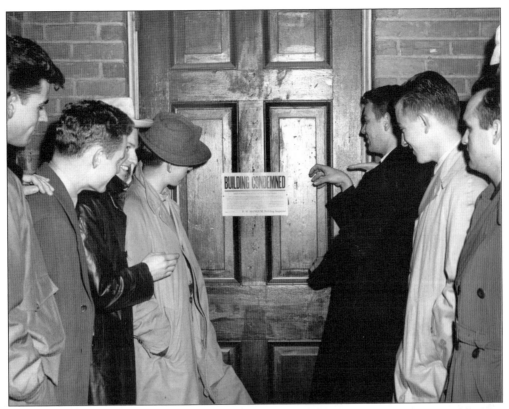

NC State officials crammed more temporary seats into Thompson, bringing it up to a total seating capacity of 4,000. Then, for the second time in two years, a game with a conference rival was canceled. Less than five hours before the Duke game on January 17, 1948, the city building inspector condemned Frank Thompson Gym. He said that the fire exits were improper, no matter how many seats were added, and the building was not fit to be occupied by more than 1,200 people. (Courtesy of NCSU Libraries' Special Collections.)

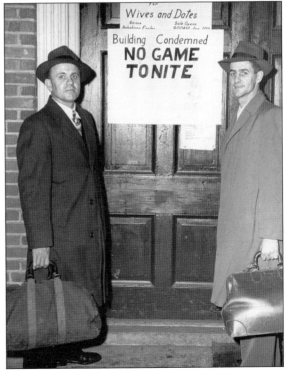

Even the game referees Bunn Hackney (left) and Dick Cullers were caught by surprise at the cancellation. (Courtesy of NCSU Libraries' Special Collections.)

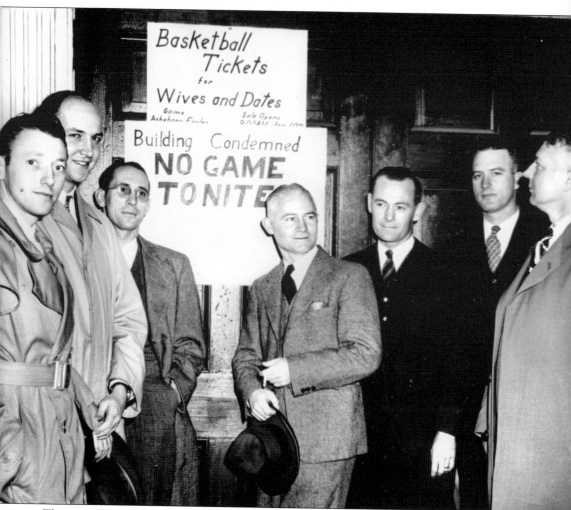

The cancellation of the NC State-Duke game spoiled the plans for this group of disappointed fans. Pictured from left to right are Gene Bateman of Fayetteville, Fred Cooper of Roanoke Rapids, H.C. Brown of Fayetteville, E.B. "Ned" Manning, Byron Gurley, and Ed Shaw, all from Roanoke Rapids, and J.H. Mobley of Winterville. The next scheduled home game against High Point College would be the last in Thompson, and it was played behind locked doors. Only a few college officials and reporters were allowed to witness the game. Fans milling about outside the building would hear only the swish of nets as the Wolfpack set a scoring record in their 110-50 victory. Case would end his first year at NC State with a record of 26-5, a Southern Conference championship, and a berth in the NIT (a more prestigious tournament at the time than the NCAA). Case's team would earn a third-place finish in the NIT, where he lost to Kentucky and The Baron—Coach Adolph Rupp. That was the last time the two legendary Southern coaches competed on the court. (Courtesy of NCSU Libraries' Special Collections.)

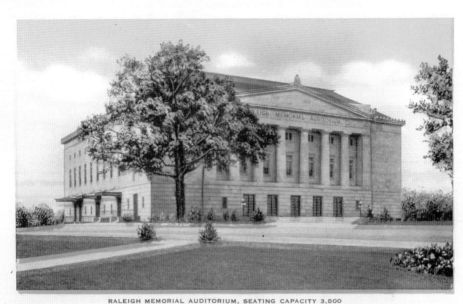

RALEIGH MEMORIAL AUDITORIUM, SEATING CAPACITY 3,800

With Thompson Gym condemned and Reynolds unfinished, NC State teams played their home games in the 3,500-seat Memorial Auditorium in downtown Raleigh.

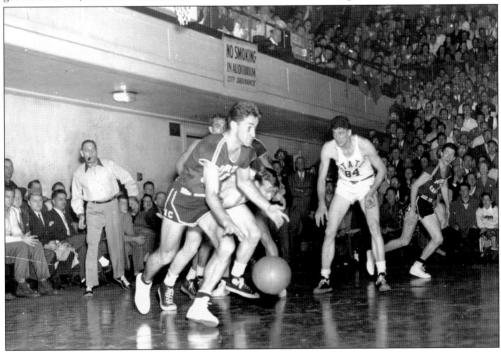

Sell-out crowds, like the one in this photo, were common in Memorial Auditorium. The Wolfpack continued to dominate Southern basketball, the 1947–1948 team finished 29-3, were Southern Conference champions again, and rated number one nationally during much of the season. (Photo by Bugs Barringer; courtesy of David Chicelli.)

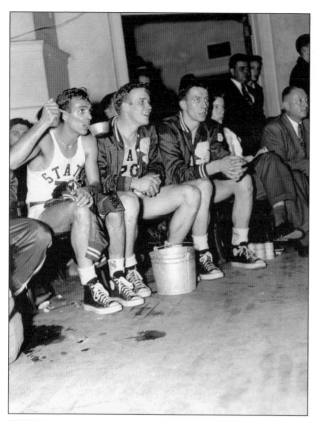

Players are pictured taking a dipper of water in Memorial Auditorium. From left to right are Jack McComas, Dick Dickey, and Warren Cartier. (Photo by Bugs Barringer; courtesy of David Chicelli.)

Case's teams continued to win, bringing unprecedented visibility to NC State. The 1948–1949 team had so much talent that even the student manager was a former all-state player from Indiana. They went 25-8 and won another Southern Conference title despite playing all of their home games at Memorial Auditorium. From left to right are (front row) McComas and Dickey; (back row) Assistant Manager Tatum, Garrison, Harand, Cartier, Stine, Hahn, Bubas, Ranzino, Horvath, Coach Case, and Manager White. (Courtesy of NCSU Libraries' Special Collections.)

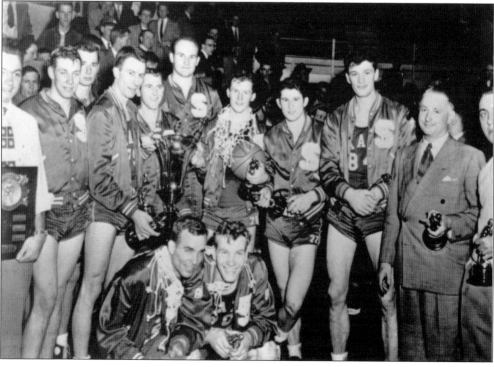

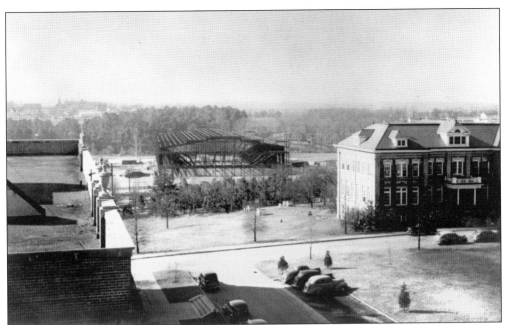

On June 12, 1948, Governor R. Gregg Cherry authorized NC State officials to "proceed immediately" with the construction of Reynolds. College officials opened construction bids within 10 days of getting the go-ahead. By this time the changes in student demographics threatened to make NC State's dream of a comprehensive coliseum undersized and obsolete before it was completed. As a result, several drastic changes were made to the plan. (Courtesy of NCSU Libraries' Special Collections.)

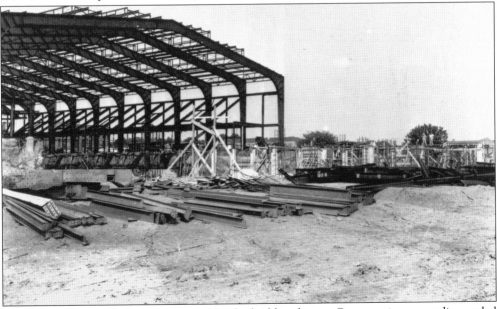

The first change for Reynolds was to make the building bigger. Construction crews dismantled the entire south end of the steel framework and added three additional 26-foot sections. The end members were replaced as they now stand, adding an additional 3,000 seats. (Courtesy of *The Raleigh News and Observer.*)

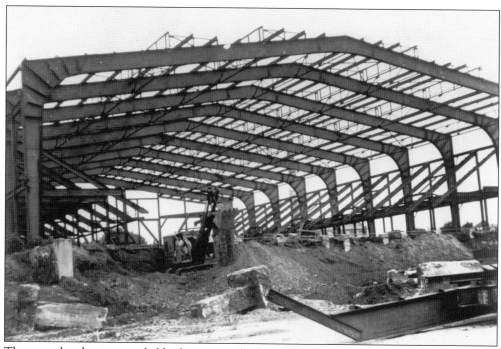

The second and most remarkable change was the decision to add a basement after the foundation and ironwork were already completed. Steam shovels and bulldozers were called to the site to dig out from beneath the steel framework and 440 tons of additional steel was installed to provide support for the floor that was originally designed to rest directly on the ground. (Courtesy of NCSU Libraries' Special Collections.)

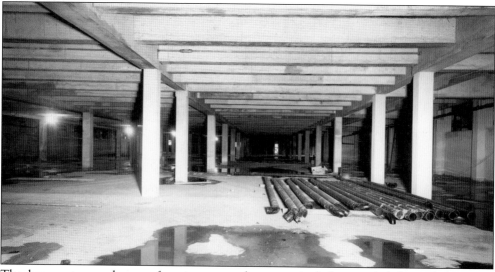

The basement served many functions over the years, including civil defense shelter, rifle range for the ROTC, batting cage for the baseball team, long jump pit, maintenance shop, cafeteria, and even sleeping quarters for the elephants when the circus was in town. Former athletic director Willis Casey recalled that the basement went through a period of inactivity to rid it of flies after the elephants' departure one particularly hot summer. (Courtesy of NCSU Libraries' Special Collections.)

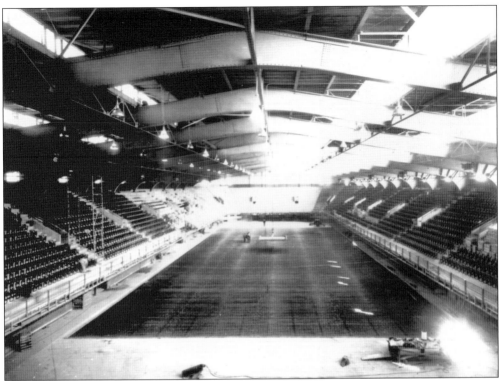

The third change made to Reynolds Coliseum was to add a full-size hockey freezing-floor. At the building's dedication, Controller Carmichael stated, "Competent observers long have been convinced that widespread participation in sports made Americans the great soldiers, sailors and fliers they were in World War II . . . and ice skating is perhaps the greatest of all the 'motor skill' sports. Good ice skaters invariably make great aviators." (Courtesy of NCSU Libraries' Special Collections.)

The ice-making equipment could produce 380,000 pounds of ice every 24 hours, and there were 12 miles of pipe in the floor for freezing the ice rink. The ice-making equipment, along with the other changes, caused the construction costs to balloon. Another appeal was made to Mrs. Babcock, who came through with an additional $52,000. North Carolina and college sources covered the remainder. The final cost for the building came to approximately $3,000,000—10 times the original estimate. (Courtesy of *The Raleigh News and Observer*.)

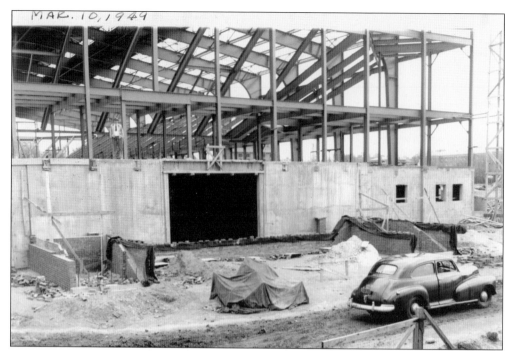

MAR. 10, 1949

One morning in 1949, after inspecting the Reynolds construction site, David Clark approached G.H. Dunlap in the textile building and asked, "How tall is an elephant?" Dunlap went to an encyclopedia, and reported back, "Twelve feet." The next day, workmen were pulling down the brickwork over the west entrance. When the contractor asked what they were doing, the foreman replied, "Some old fool says we got to raise the doorway to 14 feet, in order to get the circus in here." (Courtesy of NCSU Libraries' Special Collections.)

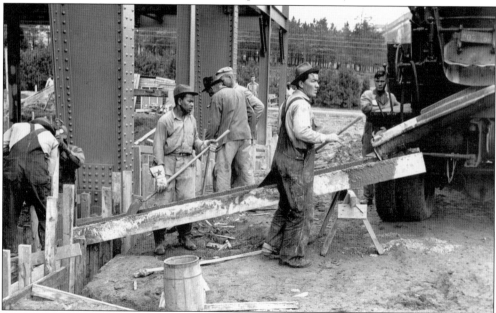

Workers pour concrete to form the basement walls in this 1949 photo. (Courtesy of NCSU Libraries' Special Collections.)

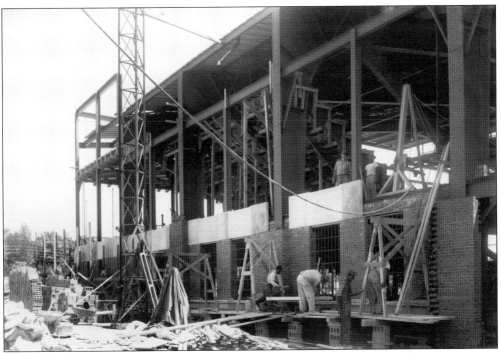

University officials found it necessary to upgrade many of the original plans for the electrical, sound, and lighting systems to serve a facility the size of Reynolds. With the budget already exhausted, much of the equipment was salvaged from military surplus. Included in this inventory were the steel stage supports fashioned from military hospital beds and additional lights that were salvaged from dismantled Army facilities. (Courtesy of NCSU Libraries' Special Collections.)

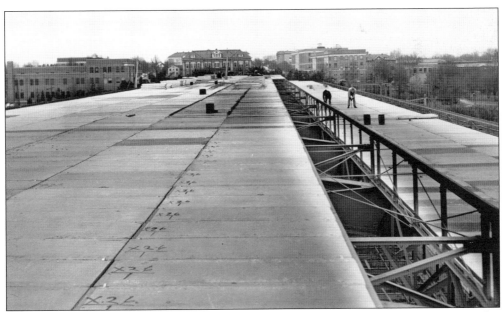

Construction workers set pre-cast and numbered concrete roof panels in place in this March 2, 1949 photograph. (Courtesy of NCSU Libraries' Special Collections.)

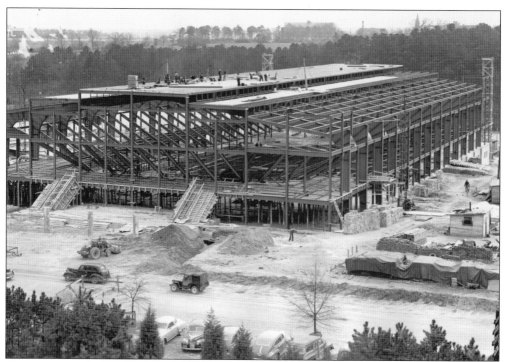

Construction progress is seen on March 17, 1949. Workers set concrete roof panels in place. The four columns that will support the roof over the front entrance are in place. (Courtesy of NCSU Libraries' Special Collections.)

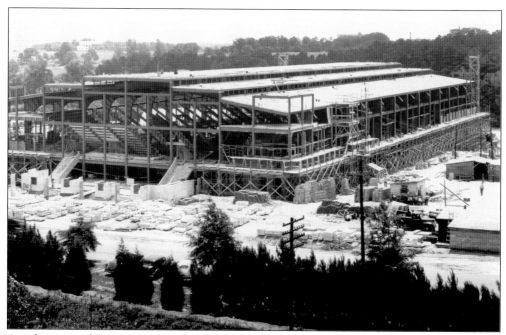

Another view of the construction, taken May 20, 1949, shows the roof in place as stonework and brickwork proceed. (Courtesy of NCSU Libraries' Special Collections.)

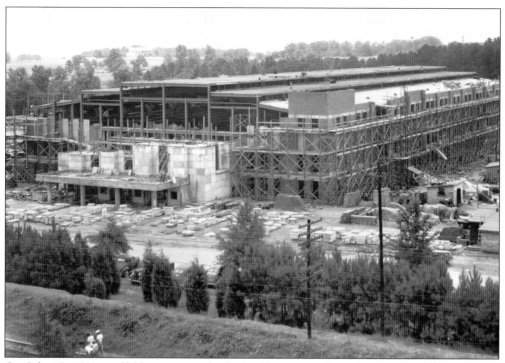

On July 15, 1949, scaffolding surrounds the building as workers close in the sides and ends. (Courtesy of NCSU Libraries' Special Collections.)

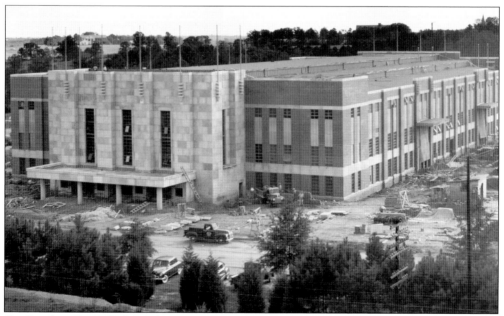

On October 10, 1949, the Coliseum is seen only two months away from tip-off. (Courtesy of NCSU Libraries' Special Collections.)

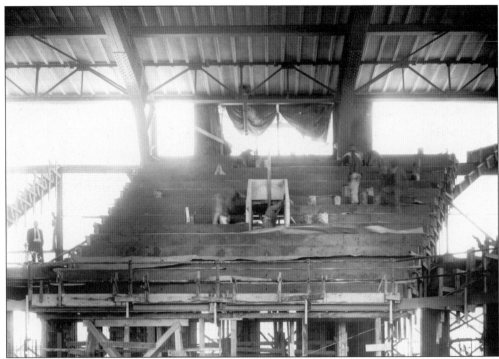

Concrete for the bleachers was poured in to wooden forms, one section at a time. This photo was taken on May 12, 1949. (Courtesy of NCSU Libraries' Special Collections.)

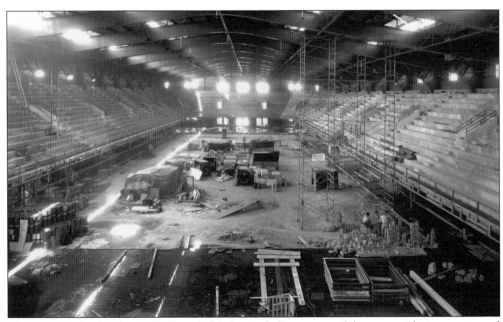

The Coliseum had its share of bells and whistles, including a state-of-the-art ventilation system and booths for radio and television broadcasting. It also featured a Hammond organ and a sound system designed and built in a collaborative effort between engineers from Western Electric Company and NC State engineering faculty. (Courtesy of NCSU Libraries' Special Collections.)

Everett Case wasn't the only Indiana legacy in Reynolds Coliseum. The building's front facade and other structural members were built from limestone quarried in south central Indiana. (Courtesy of NCSU Libraries' Special Collections.)

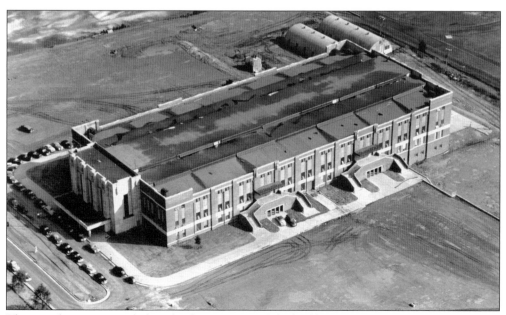

This aerial view gives a feeling for the enormity of the building. The Coliseum boasted 195,754 square feet and had 12 acres of parking. (Courtesy of NCSU Libraries' Special Collections.)

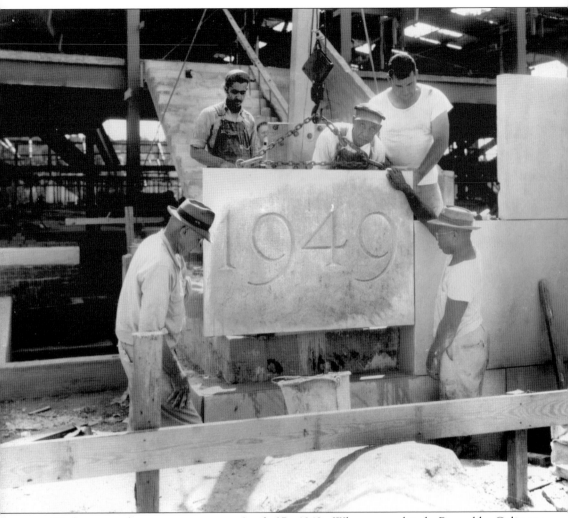

Workers set the cornerstone on April 27, 1949. When completed, Reynolds Coliseum was the eighth-largest on-campus college gymnasium in the country. It could seat 12,500 for basketball, 10,000 for ice shows, or 14,000 for speaking events. (Courtesy of NCSU Libraries' Special Collections.)

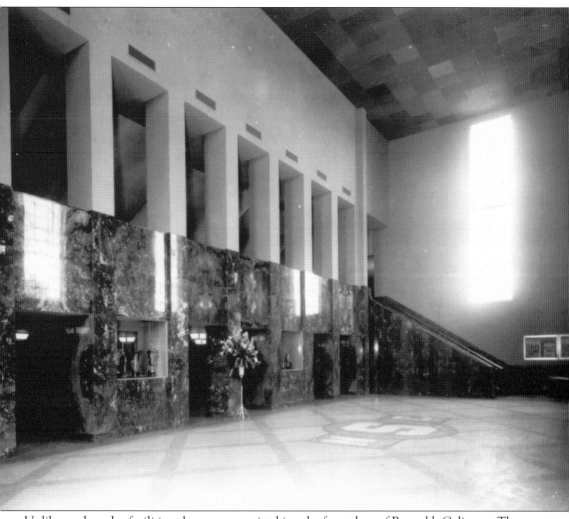

Unlike modern-day facilities, there was no mistaking the front door of Reynolds Coliseum. The towering three-story lobby was a fitting entrance for this regal building. The marble walls and brass railings gleamed as fans streamed into the building on a game day. (Courtesy of NCSU Libraries' Special Collections.)

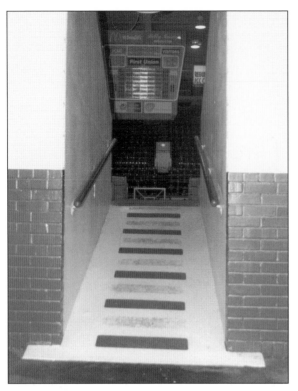

From the concourse, fans squeeze their way through one of the 22 narrow portals that lead into the main arena. The floors in the passageways jut sharply upward, giving fans the feeling of launching from a high diving board and into the sea of seats that is the interior of Reynolds Coliseum.

Elegant brass numerals inset into the concrete steps are now worn smooth from a half-century of shoes.

Three

OPENING THE DOORS

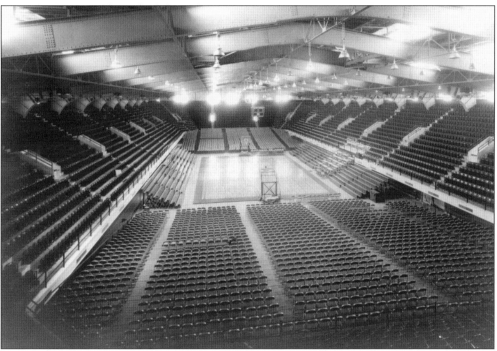

An article in the 1949 *Statelog* said it best: "Ten years in the making, the mammoth indoor stadium is the largest building of its kind between Atlantic City and New Orleans . . . But there is one spectacle that surpasses all the color and glamour that this hall of the people and palace of spectacles can produce. It is the expression on the faces of a school bus full of young boys and girls from a country high school on the banks of the Yadkin or the shores of the Chowan as they walk into the north balcony of the gigantic building and gaze south across its 12,500 silent seats to the southern balcony 400 feet away . . . There is something new, alive, refreshingly free of the blasé in the viewing eyes of a young boy from RFD Lumberton or a young girl from RFD Burlington viewing their NC State College Coliseum for the first time." (Courtesy of NCSU Libraries' Special Collections.)

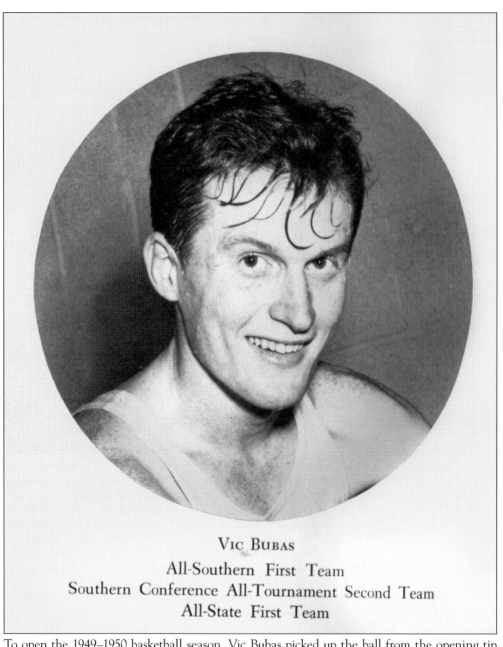

Vic Bubas
All-Southern First Team
Southern Conference All-Tournament Second Team
All-State First Team

To open the 1949–1950 basketball season, Vic Bubas picked up the ball from the opening tip and scored to start the game against Washington and Lee. It was December 2, 1949, and Bubas owned the first varsity basket scored in William Neal Reynolds Coliseum. He recalls, "I think I got the ball off the opening tip or maybe someone passed it to me off the tip. I took one or two attempts at it and I think I got the thing in on the third try. After going over to Reynolds every day and watching every brick go up in that building, I knew that if I had the ball I was going to shoot. Coach Case took me out later on in the game made me sit next to him and he said, 'You really wanted that first damn basket didn't you?' I know I didn't need to apologize to him for not passing off, because every day I was over checking the progress of the building, I could count on seeing Coach Case there walking around, doing the same thing." (*Agromeck* photo.)

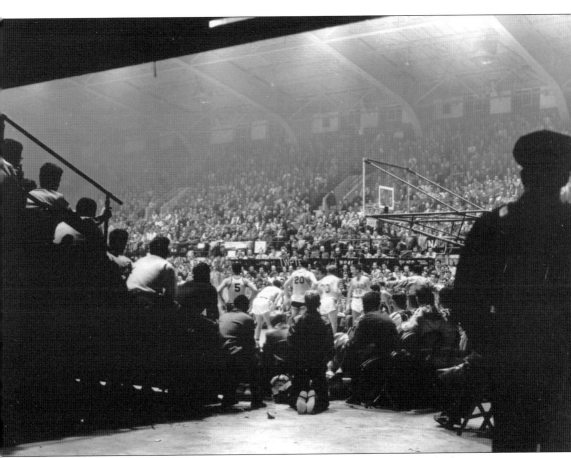

A crowd of 11,020 turned out for the opening game on December 2, 1949—the largest ever to see a basketball game in the Southeast. Fans packed into the building wearing their evening clothes, some sitting on cement tiers since the seats were not yet installed in one section of the building. NC State officials were not sure that the building would be ready for the first game, so they rented out Memorial Auditorium in downtown Raleigh as a back-up. Since Memorial only seated 3,500, only season ticket holders (and no students) would have been able to attend the game. Hoping it would not come down to that, NC State paid construction workers overtime wages to rush the final details, and took out a special insurance policy to cover players and fans. Fans had their choice of three ticket prices: 50¢, $1, or, for the best seats, $1.50. NC State defeated Washington and Lee 67-47 to win its first game in William Neal Reynolds Coliseum. (Courtesy of NCSU Libraries' Special Collections.)

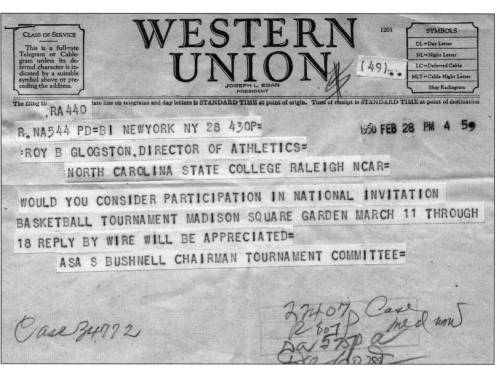

The filing ti late line on telegrams and day letters is STANDARD TIME at point of origin. Time of receipt is STANDARD TIME at point of destination

, RA 440

R. NA544 PD=B1 NEWYORK NY 28 430P= 1950 FEB 28 PM 4 59

:ROY B GLOGSTON, DIRECTOR OF ATHLETICS=

NORTH CAROLINA STATE COLLEGE RALEIGH NCAR=

WOULD YOU CONSIDER PARTICIPATION IN NATIONAL INVITATION
BASKETBALL TOURNAMENT MADISON SQUARE GARDEN MARCH 11 THROUGH
18 REPLY BY WIRE WILL BE APPRECIATED=

ASA S BUSHNELL CHAIRMAN TOURNAMENT COMMITTEE=

NC State turned down this 1950 NIT bid to play instead in the NCAA tournament. By this time, the NCAA tournament carried more prestige than the NIT. (Courtesy of NCSU Libraries' Special Collections.)

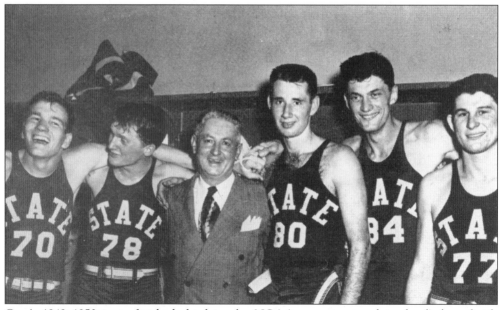

Case's 1949–1950 team finished third in the NCAA tournament, the school's best finish ever, and completed the season at 27-6. That year CCNY won both the NIT and the NCAA championships—and they beat Bradley in both championship games. (*Agromeck* photo.)

On April 22, 1950, Reynolds Coliseum was formally dedicated to the spirit, culture, science, industry, agriculture, and recreation of North Carolina. The ceremony was held during the intermission of an ice show known as Ice Cycles of 1950. (Courtesy of NCSU Libraries' Special Collections.)

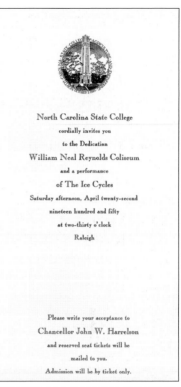

North Carolina State College

cordially invites you

to the Dedication

William Neal Reynolds Coliseum

and a performance

of The Ice Cycles

Saturday afternoon, April twenty-second

nineteen hundred and fifty

at two-thirty o'clock

Raleigh

Please write your acceptance to

Chancellor John W. Harrelson

and reserved seat tickets will be

mailed to you.

Admission will be by ticket only.

This photo shows the ice floor being prepared for the dedication ceremony. The ice-making equipment was eventually removed from Reynolds. The humidity from the ice made the basketball floor warp and caused large chunks of insulation to fall from the ceiling. (Courtesy of NCSU Libraries' Special Collections.)

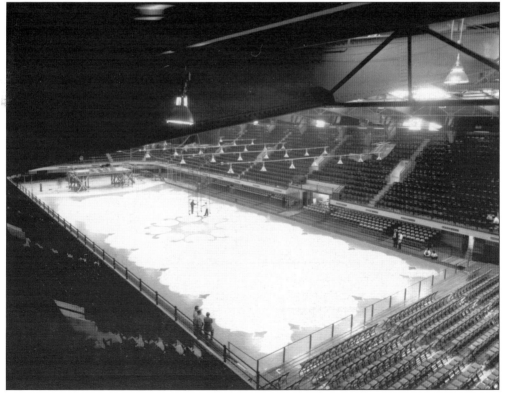

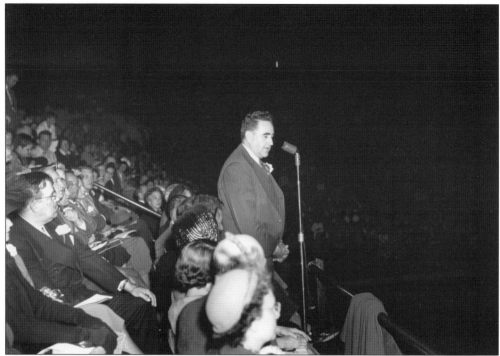

Gov. W. Kerr Scott (shown in upper photo) spoke briefly during the ceremony, as did Gordon Gray (below), president-elect of the Consolidated University, as well as Chancellor Harrelson, James A. Gray, chairman of Reynolds Tobacco Company, and controller W.D. Carmichael. Sadly, William Neal Reynolds was not present for the dedication of the building named in his honor due to illness. (Courtesy of NCSU Libraries' Special Collections.)

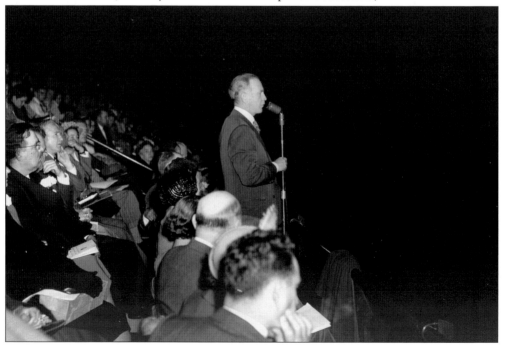

This is the dedication program cover from April 22, 1950. (Courtesy of NCSU Libraries' Special Collections.)

WILLIAM NEAL REYNOLDS COLISEUM,

DEDICATED TO THE SPIRIT, CULTURE,

SCIENCE, INDUSTRY, AGRICULTURE,

AND RECREATION OF NORTH CAROLINA

On the day the building was dedicated, an article in *The Raleigh News and Observer* quotes coliseum manager W.Z. Betts as emphasizing "that the coliseum is not a gymnasium and will not be used as such. It will be used for the promotion of educational, professional, and cultural affairs as well as for sports attractions and entertainment." J.G. Vann, the NC State college business manager agreed, saying, "There was never any thought of the coliseum being an athletic building." (Courtesy of NCSU Libraries' Special Collections.)

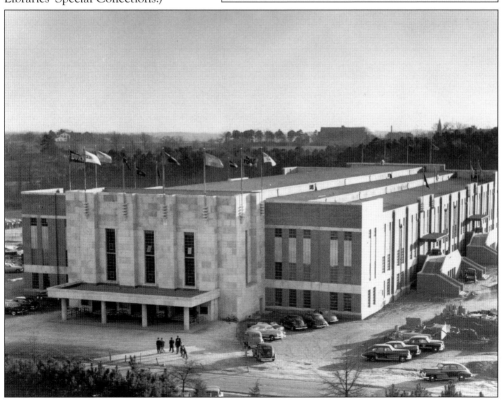

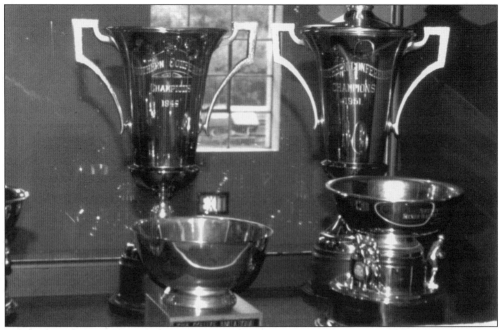

Someone forgot to tell that to the people of North Carolina. By that time, 230,000 spectators had witnessed basketball games in Reynolds. (According to the *Agromeck*, this was a new national attendance record.) Neither Betts nor Vann could have foreseen the impact that Coach Case would have on Reynolds Coliseum. Although the building would host presidents and movie stars, it became famous as the home of the Wolfpack, and the Mecca of Southern basketball.

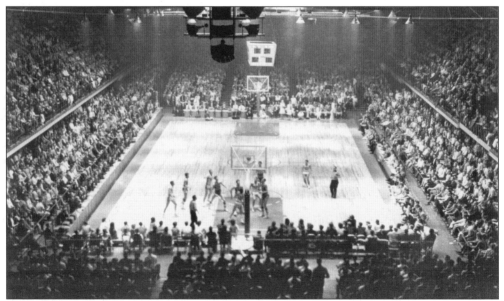

A 1951 article in *The Saturday Evening Post* said, "The floor is so brightly lit that NC State can and does take color movies of the game. Before leaving for away games the team practices with only part of the lights turned on to prepare itself for the dimmer lighting encountered in other arenas." (Courtesy of NCSU Libraries' Special Collections.)

This panel controlled the huge exhaust fans designed to change the air in Reynolds every 15 minutes. Since every seat in Reynolds was a designated smoking seat, the exhaust fans could not keep up with the smoke, and, for most games, a blue haze hung over the court.

Eight steel compartments known as "barges" were installed in the building's rafters to house press and game equipment operators. The bottoms of these barges are visible in this photo.

Some of the seats in Reynolds required fans to contort themselves a bit in order to watch the action on the court. This view is partially blocked by the stairs and hatchway leading to one of the press barges.

The elephant door on the west side of Reynolds is shown in this photo. The doors open on to a short passage that leads directly to the court surface inside.

Instead of using the bench seats that were typical in gymnasiums of that era, Reynolds featured individual fold-down seats with armrests and plenty of legroom. (*The Technician* photo.)

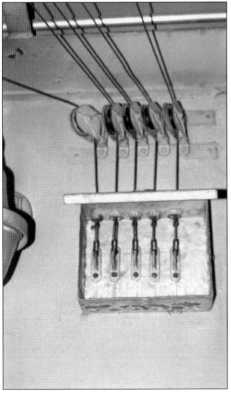

Careful observers will notice plenty of quirks in the old arena. More than 30 cable boxes, like this one, use a system of cables and pulleys, making it possible to change the arena lights without the use of ladders or scaffolding.

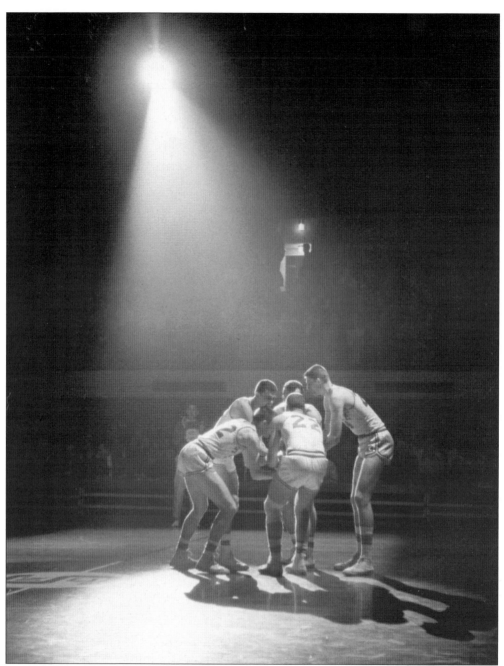

Case initiated several tactics to fire his teams up and let the other team know they were playing in the big time—many of these he brought from his native Indiana. He was the first to use a spotlight to introduce the starting players. NC State was the first school in the region to use a pep band. Reynolds also had the largest model Hammond organ available, which North Carolina coach Frank McGuire once said was worth 10 extra points to NC State each time the organist played "Dixie." Case even flew the banners of conference schools on the front of Reynolds. (He was sometimes known to fly the Carolina flag at half-mast.) (Courtesy of NCSU Libraries' Special Collections.)

One memorable feature of Reynolds was the "noise meter," a vertical row of light bulbs suspended from the ceiling. The louder the crowd became, the higher the light level would climb. The fans would raise the din in the building during a Wolfpack rally, and the noise of the crowd would feed on itself as fans tried to light up the red bulbs at the top of the meter.

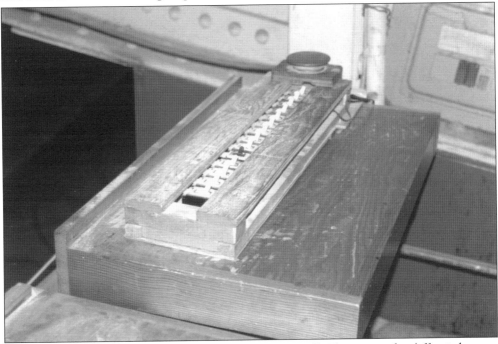

The sound meter is used to this day, but is not a meter at all. This series of on/off switches was controlled by an operator in the press barge who would manually illuminate more bulbs by sliding the handle further down the row of switches.

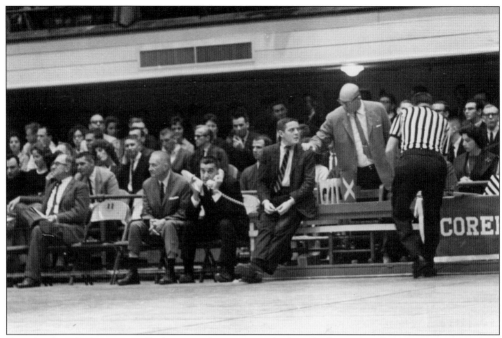

Case had a telephone installed next to his seat on the bench (being used in this photo by Press Maravich) and used it to contact assistant coaches positioned in a press barge, thinking they might have a better perspective of defensive patterns being used by the other team. Opposing teams began to complain that Case was gaining an advantage by having use of a phone, and argued that it should be removed. (*Agromeck* photo.)

As usual, Case refused to move backward, but instead he dared other coaches to keep up with him. Rather than have the phone removed, Case responded by offering to install a phone on the visitors' bench, inviting other coaches to use the phone if they thought it would help them. This was typical of Case, demanding that others keep up with him rather than giving up ground.

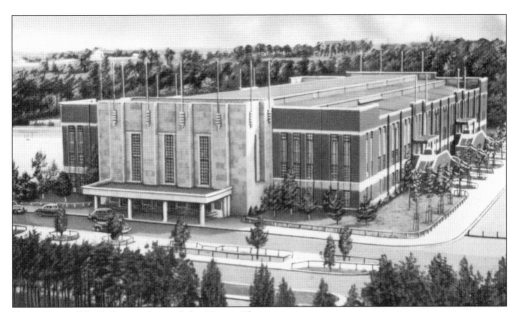

Since Reynolds Coliseum hosted the Dixie Classic and ACC tournament, the Wolfpack spent most of the season on their home floor. From 1954 through 1960, Case never played more than 10 games each season outside the brick walls of the coliseum. During that time, NC State had a 108-22 record at home for a winning percentage of .831. When forced to play on the road, their mark during that period was 36-29, a winning percentage of only .554. (Courtesy of Karl Larson.)

According to Vic Bubas (shown here in game action), on a bumpy flight back from a losing effort at West Virginia University, he was chuckling to himself in his seat. Coach Case turned to him and asked what he found so funny. Bubas replied with an impromptu poem, "Oh how much better I feel, when we play our games in William Neal." Case turned back in his seat and said, "Damn if that ain't true . . ." (Courtesy of NCSU Libraries' Special Collections.)

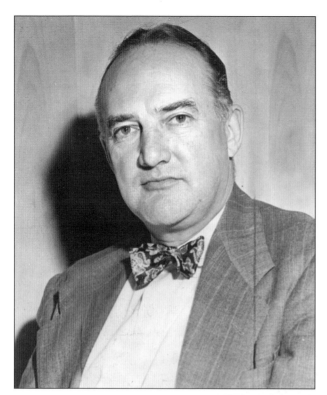

Ken Loeffler brought his highly ranked LaSalle team to Reynolds in 1951. NC State seemed to be getting the breaks in the officiating. (At that time, the officiating duties for all the games in Reynolds were handled by a few select individuals hired by Case.) Loeffler grew increasingly irate at the official's judgment as NC State increased their lead and ultimately defeated the LaSalle team. (Courtesy of LaSalle University Archives.)

When the game ended and the visitors headed back toward their locker room, Loeffler could not stomach the thought of walking the length of the court past the Wolfpack fans. Instead, the LaSalle coach turned and stormed out behind his team's bench and out through the front entrance of the Coliseum to the railroad tracks that bisect the campus. He followed the tracks all the way back to his downtown hotel. In this photo, Reynolds is barely visible in the upper left corner. (Courtesy of NCSU Libraries' Special Collections.)

Four

THE DIXIE CLASSIC

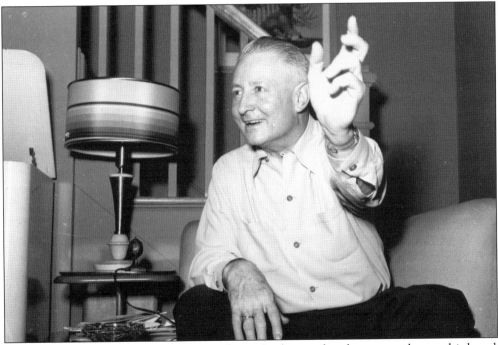

Everett Case regularly invited visiting coaches to his house after the game to have a drink and talk basketball, as long as the visiting coach could keep up with him in either activity. More than anything, Case loved to talk basketball, watch basketball, and talk about it some more. After practice in Reynolds, he would jump in the car and ride along with his assistant coaches and announcer C.A. Dillon to Chapel Hill, Durham, Wake Forest, or wherever there was a game that night. He was as regular a fixture in Woolen Gym, Duke Indoor Stadium, and Gore Gym as he was in Reynolds. In most of these places, he even had reserved seats. In one memorable session in Case's living room, a group of friends came up with an idea for a tournament. Butter Anderson and the former *Raleigh News and Observer* sports editor, Dick Herbert, collaborated on the name. They would call it the "Dixie Classic." (Courtesy of *The Raleigh News and Observer*.)

First Annual
Dixie Basketball Classic
December 28, 29, 30, 1949

William Neal Reynolds Coliseum
North Carolina State College
Raleigh

Official Program 25¢

Everett Case was becoming as well known for his promotion of basketball as much as for his coaching prowess. In his native Indiana, the state high school basketball tournament was the focus of life. With giant Reynolds Coliseum as the tournament's home, Case saw a huge potential for the Dixie Classic. He was confident enough in its chances to label the 1949 tournament the "first annual" Dixie Classic. (Courtesy of NCSU Libraries' Special Collections.)

NC State invited four of the top ranked teams in the country to play the "Big Four" schools of North Carolina: Duke, NC State, Carolina, and Wake Forest. The format was 12 games in 3 successive days to be held during the normally inactive period between Christmas and New Years Day. Each of the Big Four schools would play one of the out-of-state teams in the first round with the winner advancing. (Courtesy of NCSU Libraries' Special Collections.)

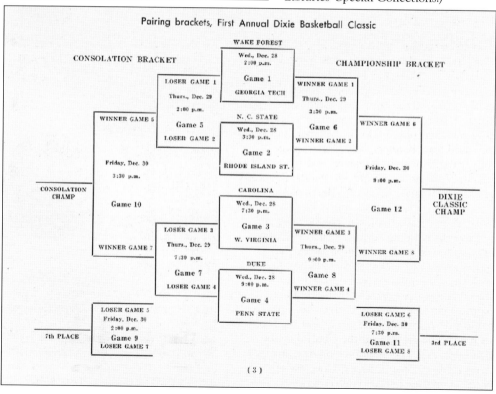

Pairing brackets, First Annual Dixie Basketball Classic

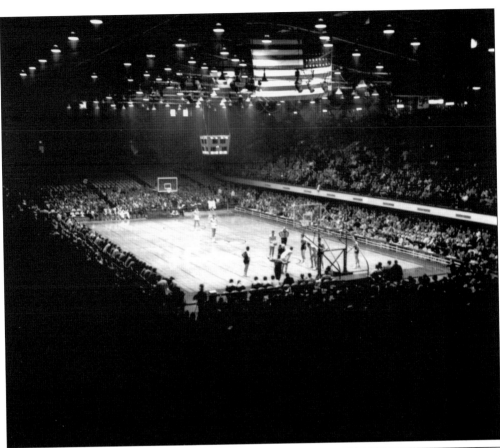

The Dixie Classic was an overwhelming success. Crowds of 75,000 or more were typical for the tournament. The festivities made Raleigh not only a sports Mecca but also a social and shopping event. There were pretournament parties and after-game receptions. Downtown merchants displayed team banners, held Dixie Classic sales, gave away prizes at games, and sponsored hospitality areas for out-of-town guests. (Courtesy of NCSU Libraries' Special Collections.)

With all that basketball, fans barely had time to leave the building during the day. NC State officials served up North Carolina barbecue in the massive basement of the building so fans would not miss a single shot. Always the promoter, Case decided there would be halftime entertainment at each game. The entertainers for the 1953 tournament included such headline-grabbers as the Central Prison Band, Mr. A.B. Harrington's Dog Act, and Homer Briarhopper & Band. (Courtesy of NCSU Libraries' Special Collections.)

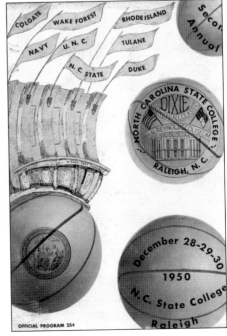

Kirklin, Indiana
March 30, 1951

Dear Roy:

I forgot to mention to you when I wrote yesterday and sent you the itinerary, that I would like for you to write Bill Hunter right away and give him the full dope on the Dixie Basketball Classic for next December 27, 28, 29, formally inviting them to participate. Tell him that I talked at length with Forrest Twogood, So. Calif coach, and that Twogood is planning to come with the permission of Hunter.

Tell him that Columbia, Cornell and Navy are to be the othre three schools. Navy was very anxious to return so I sewed up that deal in Minneapolis. Also give him the dope on the financial end. I agreed to give So. California a flat fee of $2,000 plus 10% of the net. They are planning a trip on the way back to play Ok. A. and M and also Kansas and Texas.

Tell Bill that we would like to h have definite word from them within the next ten days.

With them coming in, and with Columbia, Cornell and Navy, we should have a dandy tourney.

Sincerely,
Everett

As this letter shows, much of the scheduling was done personally by Case. He was well connected in the basketball world, and he was able to bring big name schools to Raleigh informally, as this letter demonstrates. Even as a high school coach, Case had a wide network. He founded the Indiana Coaching School, which, for years, was the largest basketball coaching school in the nation. A few of Case's notable guest presenters included John Wooden, Cliff Wells, and Phog Allen. (Courtesy of NCSU Libraries' Special Collections.)

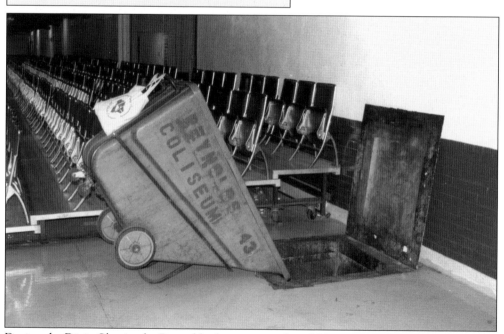

During the Dixie Classic, the Reynolds cleaning crew hired 30 extra people to begin at 11 p.m. and finish at 6 a.m. after sweeping steadily all night. They were relieved by a second crew that would work right up until the start of the first game of the day. Foresighted planners included trap doors in the coliseum floor for a variety of uses, including the removal of ice from the hockey floor, dumping of trash, and even the removal of elephant manure during the circus.

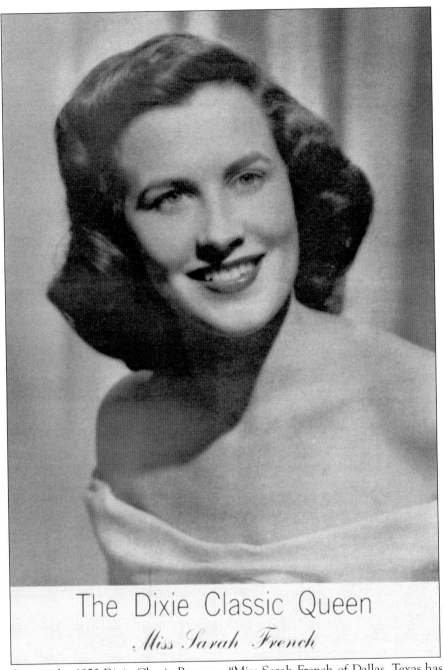

The Dixie Classic Queen
Miss Sarah French

According to the 1950 Dixie Classic Program, "Miss Sarah French of Dallas, Texas has been selected as the first Queen of the Dixie Classic. She is a co-ed at Tulane University at New Orleans, La. And was selected to represent the institution as a candidate by the Tulane "T" Club. Miss French . . . is 22 years old. She was also elected as Tulane's Homecoming Queen of 1950 during a recent contest held on campus. Miss French will be the guest of the eight teams involved in the Dixie Classic for the three-day tournament." The queen was entitled to travel expenses, lodging, and a fresh corsage every day. Her official duty was to present trophies on the final day of the tournament. (Courtesy of NCSU Libraries' Special Collections.)

The person who owns the longest association with Reynolds Coliseum is former public address announcer C.A. Dillon. A Raleigh businessman, Dillon started his avocation in Thompson Gym as a student in 1947. He remained behind the microphone throughout the entire 50-year history of Reynolds Coliseum, including all 12 Dixie Classic tournaments. (Courtesy of the *Greensboro News and Record*.)

THE AMERICAN NATIONAL RED CROSS

.... *Wake County Chapter*

May 22, 1958

301 NORTH BLOUNT STREET
RALEIGH, NORTH CAROLINA
TELEPHONE TEmple 3-3015

Dr. Joseph J. Combs
Doctor-in-charge, First Aid Station
N. C. State College Coliseum
Professional Building
Raleigh, North Carolina

Dear Dr. Combs:

Listed below is the statistics on activity at the First Aid
Station, N. C. State College Coliseum, for 1957-1958:

The First Aid Station was staffed through Wake
County Chapter, American Red Cross, with volun-
teer Registered Nurses for the Coliseum events
from October 1957 through March 1958.

18 events took place during these months

223 hours of volunteer Nursing services rendered

66 volunteer registered nurses rendered service

171 persons received First Aid treatment

The chart below will indicate the number of persons
receiving First Aid each month during the events:

```
October . . . . . . .  11
November . . . . . . .   3
December . . . . . . .  74
January . . . . . . .    5
February . . . . . .    16
March . . . . . . . .   62

TOTAL . . . . . . 171 .
```

Very truly yours,

Virginia S. Snakenberg

(Mrs.) VIRGINIA S. SNAKENBERG, R.N.
Co-ordinator, Nursing Services

S/m

CC: Mr. Clogston

The Red Cross maintained a first-aid station in Reynolds Coliseum during basketball games—not for the players, for the fans. Even their business picked up in December because of the Dixie Classic. (Courtesy of NCSU Libraries' Special Collections.)

Everett Case said that he never coached a better player or person than Ronnie Shavlick. When he graduated, Shavlick held all of the Wolfpack rebounding records, was the ACC player of the year, and was a two-time All-American. He led NC State to two Dixie Classic and three ACC championships. After a brief professional basketball career, he built a hugely successful business in Raleigh. He was active in his support of civic causes and NC State University. Shavlick died in 1983 at the age of 49. (Courtesy of Burnie Batchelor.)

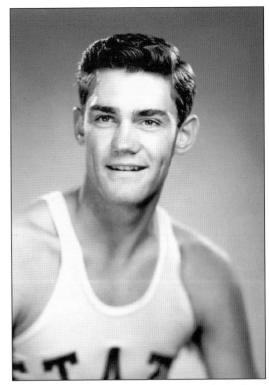

This photo shows the 1955–1956 cheerleading squad. (Courtesy of NCSU Libraries' Special Collections.)

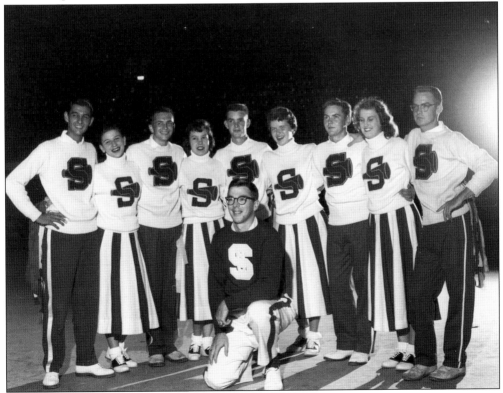

79

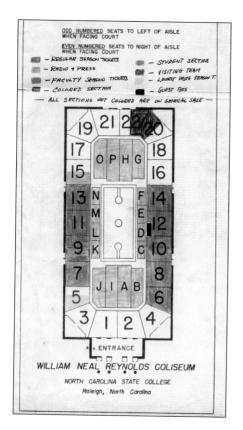

When it opened in 1949, seating was segregated in the coliseum, as shown by this seating chart. There were no black players on any Southern Conference teams, and controversy over black players participating in games in Reynolds came to the forefront early in the building's history. (Courtesy of NCSU Libraries' Special Collections.)

For several years, the Dixie Classic program cover portrayed a minstrel show theme. Northern and Western schools with black players were reluctant to come to Reynolds because of the strained racial relations in the South. (Courtesy of NCSU Libraries' Special Collections.)

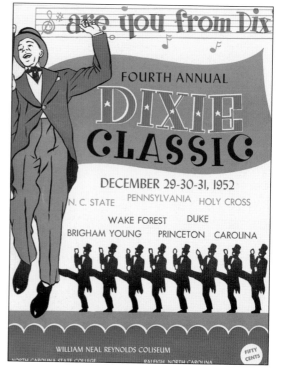

The song "Dixie," although widely used by schools in the South as an unofficial anthem to represent their attachment to the land, was also considered racist for creating nostalgia for times of slavery. The lyrics as displayed in this 1952 Dixie Classic program were particularly contentious because they are written in a supposedly black dialect. (Courtesy of NCSU Libraries' Special Collections.)

Bob Yoder, long-time Reynolds Coliseum organist, remembered being approached by a group of students in the early 1970s who asked him to stop playing "Dixie" at Wolfpack games. He complied immediately. (*The Technician* photo.)

DIXIE

First Verse

I wish I was in de land ob cot-ton,
Old times dar am not forgotten,
Looka-way! Looka-way! Looka-way! Dixie Land.
In Dixie Land whar I was born in, Early on one frosty mornin',
Looka-way! Looka-way! Looka-way! Dixie Land.

Chorus

Den I wish I was in Dix-ie, Hoo-ray! (hooray) Hoo-ray! (hooray)
In Dixie Land, I'll take my stand to lib and die in Dixie;
A-way, A-way, A-way down south in Dixie,
A-way, A-way, A-way down south in Dixie.

Second Verse

Dar's buck-wheat cakes an' In-gen bat-ter,
Makes you fat, or a lit-tle fatter,
Looka-way! Looka-way! Looka-way! Dixie Land.
Den hoe it down an' scratch your grabble,
To Dix-ie Land I'm bound to trabble,
Looka-way! Looka-way! Looka-way! Dix-ie Land!

* *Repeat Chorus*

In 1958, Case scheduled powerhouse teams Cincinnati and Michigan State to play in the Dixie Classic with their respective standouts, Oscar Robertson and Johnnie Green, both black. There was still some question as to where black players could stay and eat in Raleigh, and the athletic directors from both schools sent NC State athletic director Roy Clogsdon letters stating their expectations for the treatment of their teams in no uncertain terms. Both carried the same message, but the letter from "Biggie" Munn, the AD at Michigan State, left no room for misinterpretation. With that, NC State officials arranged to house and serve meals to all visiting teams together. (Courtesy of NCSU Libraries' Special Collections.)

The 1960 Dixie Classic Program contained this description of Delia Chamberlin, the tournament's queen: "Selected as Queen of the 1960 Dixie Classic is Miss Delia Chamberlin of Memphis, Tenn., sponsored by the Varsity 'D' Club of Duke University. Delia is a junior at Duke, majoring in French. She is five-foot-five, 123-pounds, and 20 years old. The attractive co-ed is the daughter of Mr. And Mrs. Francis S. Chamberlin of Memphis." (Courtesy of NCSU Libraries' Special Collections.)

QUEEN OF THE 1960 DIXIE CLASSIC

Miss Delia Chamberlin

Selected as Queen of the 1960 Dixie Classic is Miss Delia Chamberlin of Memphis, Tenn., sponsored by the Varsity "D" Club of Duke University. Delia is a junior at Duke, majoring in French. She is five-foot-five, 123-pounds, and 20 years old. The attractive co-ed is the daughter of Mr. and Mrs. Francis S. Chamberlin of Memphis.

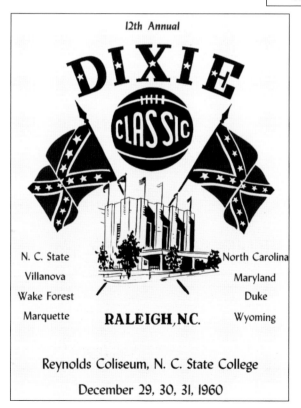

12th Annual

DIXIE CLASSIC

N. C. State
Villanova
Wake Forest
Marquette

North Carolina
Maryland
Duke
Wyoming

RALEIGH, N.C.

Reynolds Coliseum, N. C. State College

December 29, 30, 31, 1960

The greatest Christmas gift a child in North Carolina could receive was a ticket book to the Dixie Classic. Of course, Mom and Dad would remove the finals tickets for themselves. That did not matter, because the youngsters knew they were going to see part of the year's biggest event in Reynolds Coliseum. (Courtesy of NCSU Libraries' Special Collections.)

In 12 years of play, the Dixie Classic was never won by a school outside the Big Four. NC State won seven titles, Carolina won three, Duke claimed one championship, and Wake Forest, behind the play of tournament MVP Billy Packer, won the Dixie Classic in 1959. (Courtesy of NCSU Libraries' Special Collections.)

Case was the ultimate promoter of college basketball. He initiated a lady's clinic and invited women from the area to Reynolds to attend a one-evening orientation to the game of basketball. Door prizes of six season tickets were given away during the evening and no men were allowed. (Courtesy of NCSU Libraries' Special Collections.)

DEPARTMENT OF ATHLETICS
NORTH CAROLINA STATE COLLEGE
Raleigh, N. C.
November 15, 1960

Dear Friend:

The Varsity and Freshman basketball teams of North Carolina State College, along with the coaching staff, will conduct a basketball clinic for Ladies, FREE of charge, on Monday evening November 28, in the William Neal Reynolds Coliseum, State College Campus, from 8:00 to 9:00 p.m.

The basic terminology of basketball will be explained, such as demonstrations of man to man defense, zone defense, set plays, charging, blocking, pivot, jump shot, hook shot, etc. We will provide an interesting program on basketball for ladies who would like to know a little more about the game.

No men will be admitted to this clinic. The ladies in attendance will have the opportunity to meet the players personally, talk with them and have an enjoyable hour. We also plan door prizes of six season basketball tickets to all N. C. State home games which will be awarded to the ladies holding the lucky numbers.

Ladies are invited from the ages of five to one hundred and five. We will appreciate your reading this letter to your group or organization, and extending a cordial invitation to all ladies to attend. Please help us pass the word around to all the wives, daughters, sisters, sweethearts, aunts, mothers, and grandmothers. Many thanks for your cooperation and help. Yours for better spirit, interest and understanding of basketball.

Sincerely yours,

Mrs. Clifton Benson
Chairman Ladies Committee

Everett N. Case
Head Basketball Coach
N. C. State College

84

Basketball tournaments were not just sporting events in Case's era. They were always designed to include social events as well, like this 1951 Southern Conference luncheon. The invitation also welcomed people to stop by the governor's mansion the following day for coffee hosted by North Carolina's First Lady, Mrs. William Scott. (Courtesy of NCSU Libraries' Special Collections.)

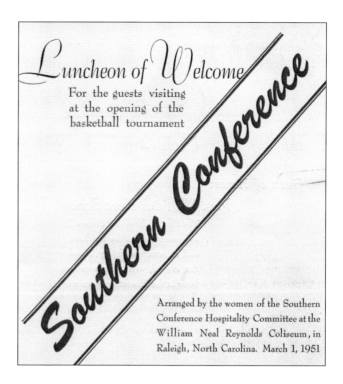

Luncheon of Welcome

For the guests visiting at the opening of the basketball tournament

Southern Conference

Arranged by the women of the Southern Conference Hospitality Committee at the William Neal Reynolds Coliseum, in Raleigh, North Carolina. March 1, 1951

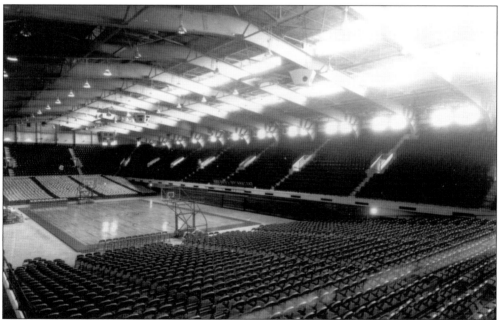

Vic Bubas remembers Case as the ultimate innovator, both on the court and off. He recalls walking to practice one day and seeing Case staring out at the empty playing floor. Case asked Bubas if he thought it would be possible to mount the court on a slowly rotating platform. That way everyone would have a courtside seat. Bubas laughed until he saw that Case was quite serious. (Courtesy of NCSU Libraries' Special Collections.)

NORTH CAROLINA STATE COLLEGE

OF AGRICULTURE AND ENGINEERING OF THE UNIVERSITY OF NORTH CAROLINA

RALEIGH

JOHN T. CALDWELL, CHANCELLOR

13 March 1961

Coach Everett N. Case
Department of Athletics
Campus

My dear Mr. Case:

I am pleased to inform you that the Executive Committee of the Board of Trustees has approved extension of your appointment as Head Basketball Coach as a contract beginning 1 February 1961 and ending 30 June 1965. No change in your present salary of $11,500 is made at this time.

As in the case of other coaches, you are responsible for insuring that all institutional policies concerning the intercollegiate athletics be maintained. That is to say, your program must at all times be in conformity with the requirements of the National Collegiate Athletic Association, with the Atlantic Coast Conference, and with the requirements of the Board of Trustees of the University of North Carolina. These policies embrace also institutional standards including those defined by the Athletics Council.

I wish you continued success in carrying forward your program.

Sincerely yours,

John T. Caldwell

JTC:ho
cc: Pres. Wm. Friday
 Dean H. B. James
 Mr. J. G. Vann
 Dir. Roy B. Clogston ✓

How times have changed. In 1961, one of the most successful coaches in the country was paid less than $12,000 per year. Case used Reynolds Coliseum to promote the excitement of basketball to the people of North Carolina, and one probably would not have succeeded to the degree it did without the other. As a result of his presence in the state, other colleges upgraded their programs to keep up. Case would speak to every civic and community group he could to promote the growth of basketball in the state. High schools built gymnasiums to keep up with the interest in the sport, and the popularity of basketball was growing like kudzu in the Tar Heel State. As an article in the 1952 *Saturday Evening Post* stated, "North Carolina State, once a sports nobody, now draws bigger basketball crowds than any other college. How was it done? By getting a whole city into the act—and importing a Yankee coach." (Courtesy of NCSU Libraries' Special Collections.)

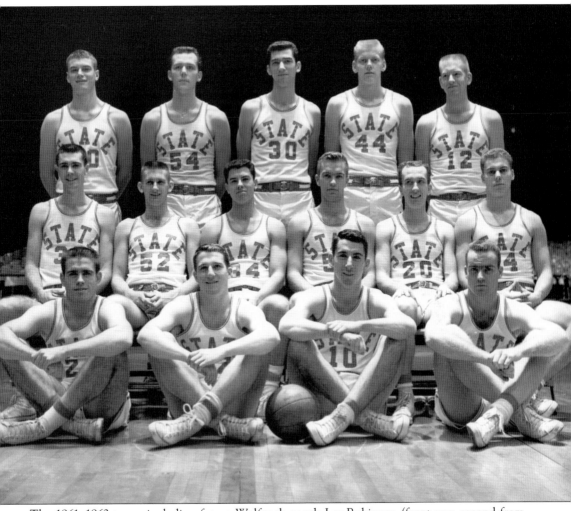

The 1961–1962 team, including future Wolfpack coach Les Robinson (front row, second from left), played an abbreviated schedule as a result of the university's attempt to de-emphasize sports. Going back to 1954, NC State was involved in a series of recruiting violations and a point-shaving scandal. The most surprising and drastic move was the cancellation of the Dixie Classic by officials at NC State and the Consolidated University. At first fans thought it was a temporary move, and that the Classic would be back after memories of the point-shaving scandal faded. When it became apparent that the event was canceled permanently, fans throughout the state were outraged. Sports writers, Raleigh merchants, and even the 1963 General Assembly were unsuccessful in their attempts to resurrect the tournament. Horace "Bones" McKinney, former Wake Forest coach, joked that he was going to run for governor on the platform of bringing back the Dixie Classic. (*Agromeck* photo.)

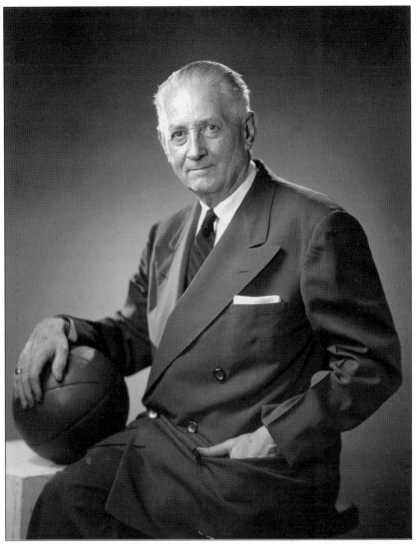

After the second game of the 1964–1965 season, Everett Case, in failing health, gave up coaching. His accomplishments at NC State were remarkable: 377 wins against 134 losses, 10 ACC and Southern Conference titles, seven Dixie Classic titles, seven of his players were named All-America, and two of them, Dick Dickey and Sammy Ranzino, won the honor for three consecutive years. NC State University, the city of Raleigh, and the ACC were fortunate that Everett Case came along when he did. As Vic Bubas said, "Not so much because of his coaching, even though he was a great coach, a hall of famer. He was the best fast-break coach there was. He arrived at a time when college basketball was in its infancy. Schools were playing in bandbox gyms and scholarships were hard to find for basketball. Most schools simply recruited football and baseball players and let them play basketball in their off season. Everett Case was a genius in promoting the game of basketball. He knew how to deliver the whole package. He had the organ music, the spotlight, the Dixie Classic, the cutting down nets—and remember, this was a heck of a long time ago. Had Everett Case chosen not to coach basketball there is no doubt in my mind that he would have been a millionaire, maybe many times over, because of his business sense, his promotion sense, and his flair." (Courtesy of Burnie Batchelor.)

Former associate athletic director Frank Weedon may have said it best, "If you ask anyone in the ACC who was responsible for the upsurge in the popularity of basketball in the Southeast, they would say Everett Case. He beat Carolina 15 straight times, then they hired Frank McGuire to bring their program up, Duke hired Bubas, and everybody tried to beat Case. You could say he forcefed big time basketball to the Southeast." (Courtesy of NCSU Libraries' Special Collections.)

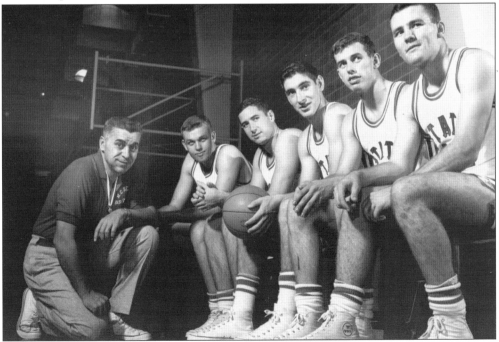

When Case stepped down from coaching in 1964, responsibility for the team went to Case's assistant, Press Maravich. Pictured from left to right are Maravich, Larry Worsley, Pete Coker, Tommy Mattocks, Eddie Biedenbach, and Billy Moffit. (Courtesy of NCSU Libraries' Special Collections.)

As this 1955 ACC tournament photo shows (left), it was a tradition for the players to carry Case over to cut the nets. Frank Weedon remembers a special moment after the 1965 ACC tournament (bottom photo): "Coach Case's health was fading fast, and he had to give up coaching after two games into the 1965 season. The team upset Duke that night even though Duke was heavily favored and ranked third or fourth in the nation. Coach Case was sitting in the first row of the press area, and the players went over and got him."They held him up and let him cut the last strand from the net. He brought that tradition here with him from Indiana, now you see it all over. That was a dramatic moment, there wasn't a dry eye in the place." (Top photo courtesy of Burnie Batchelor; bottom photo courtesy of NCSU Libraries' Special Collections.)

Everett Case died on April 30, 1966 of cardiovascular failure brought on by an accumulation of ailments. At his request, he was buried in a cemetery that overlooked Highway 70, so he could "Wish my boys well on their way to play Duke." In his will, Case threw one more trick play into the game. He divided the remainder of his estate into 103 equal units that he distributed to his former players from NC State.

In 1972, NC State started construction on the Everett Case Athletic Center. The finished building contains trophy rooms, athletic department offices, dining for athletes, and lounges. The center was built on funding organized by the Wolfpack Club and given entirely by private sources. (Courtesy of NCSU Libraries' Special Collections.)

The Case Center, viewed through a Reynolds Coliseum concourse window, is shown here. It is fitting that the buildings are next to each other. Everett Case and Reynolds Coliseum were the perfect combination of vision and capacity.

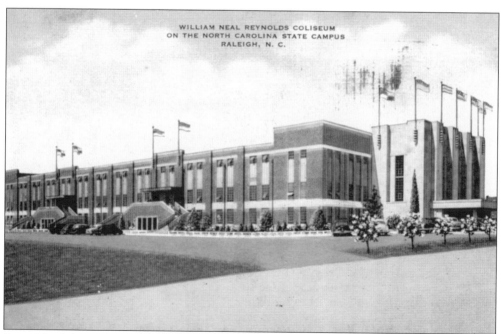

Reynolds Coliseum was such a prominent landmark that it was featured on postcards. The message on the back of this card reads simply, "It hot down here. Signed, Doris and Tom."

Five

PLOWS, PRESIDENTS, AND THE PHILHARMONIC

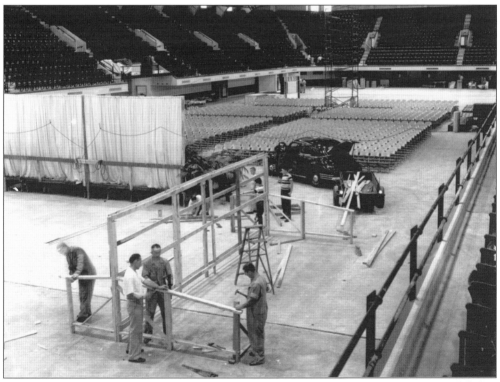

Workmen construct a display set behind the speaker's podium in preparation for Farm and Home Week in 1950. This was the first time the event was housed in Reynolds Coliseum. David Clark's 10-year-old vision for "an indoor stadium where rain or shine 10,000 farmers can get together to solve their problems, a building big enough to accommodate all kinds of agricultural exhibits, farm demonstrations, machinery display" was finally a reality. (Courtesy of NCSU Libraries' Special Collections.)

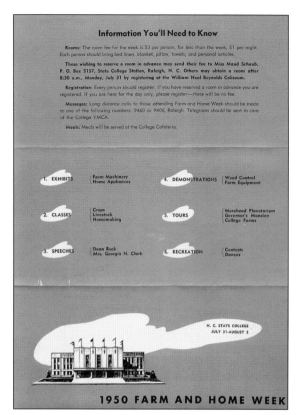

Information You'll Need to Know

Rooms: The room fee for the week is $3 per person, for less than the week, $1 per night. Each person should bring bed linen, blanket, pillow, towels, and personal articles.

Those wishing to reserve a room in advance may send their fee to Miss Maud Schaub, P. O. Box 5157, State College Station, Raleigh, N. C. Others may obtain a room after 8:30 a.m., Monday, July 31 by registering at the William Neal Reynolds Coliseum.

Registration: Every person should register. If you have reserved a room in advance you are registered. If you are here for the day only, please register—there will be no fee.

Messages: Long distance calls to those attending Farm and Home Week should be made to one of the following numbers: 9460 or 9406, Raleigh. Telegrams should be sent in care of the College Y.M.C.A.

Meals: Meals will be served at the College Cafeteria.

1. EXHIBITS	Farm Machinery / Home Appliances	4. DEMONSTRATIONS	Weed Control / Farm Equipment	
2. CLASSES	Crops / Livestock / Homemaking	5. TOURS	Morehead Planetarium / Governor's Mansion / College Farms	
3. SPEECHES	Dean Rusk / Mrs. Georgia N. Clark	6. RECREATION	Contests / Dances	

N. C. STATE COLLEGE
JULY 31-AUGUST 3

1950 FARM AND HOME WEEK

This Farm and Home Week brochure advertises some of the activities and demonstrations planned for the 1950 event and shows off a picture of its new home, Reynolds Coliseum. (Courtesy of NCSU Libraries' Special Collections.)

Two men set up a piece of farm equipment for display during Farm and Home Week. Notice the high gloss on the tires. (Courtesy of NCSU Libraries' Special Collections.)

94

The sign on the back of the truck says "See firefighting demonstration Wednesday night." The wooden sheds piled up in the Reynolds parking lot probably made a nice bonfire before they were doused. (Courtesy of NCSU Libraries' Special Collections.)

During Farm and Home week, the Reynolds Coliseum ticket window served as the check-in desk for anyone who wanted to stay in a dormitory during the week. (Courtesy of NCSU Libraries' Special Collections.)

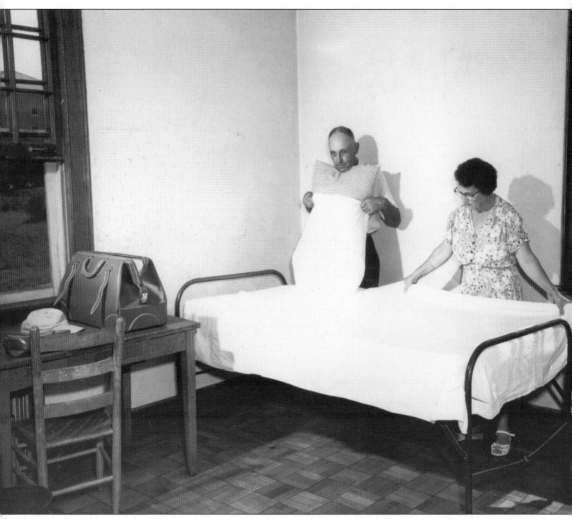

This farm couple prepares their room for Farm and Home Week. Room rental for the entire week was $3. Notice the brand new suitcase, probably purchased just for this occasion. (Courtesy of NCSU Libraries' Special Collections.)

Two events, both hosted in Reynolds, opened the doors of NC State and coaxed the citizens of North Carolina to the Raleigh campus: The Dixie Classic and the highly successful Friends of the College Series. For many years the Series claimed more members than any other university related cultural series in the country. Under the direction of Gerald Erdahl, the Series brought the best music, theater, and dance from around the world directly into Reynolds Coliseum. Now the citizens of the state could go to Raleigh to see cultural performance normally offered only in large urban markets. Started in 1959, the Friends of the College series was an instant and lasting success and offered members the opportunity to see seven shows for an incredibly low $7 annual fee. (Courtesy of NCSU Libraries' Special Collections.)

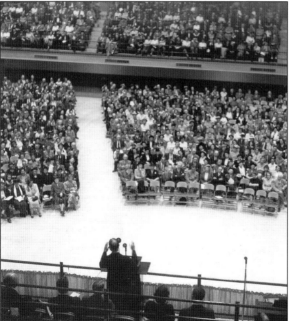

Architect Frank Lloyd Wright speaks in Reynolds on May 30, 1950. A few of the many celebrities who appeared in Reynolds in the early days included Gene Autry, Bobby Riggs, Sonja Henie, Horace Heidt, Billy Graham, Vincent Price, Van Cliburn, and Louis Armstrong. (Courtesy of NCSU Libraries' Special Collections.)

This photo shows Reynolds set up in a different seating configuration as Norman Vincent Peale addresses the crowd. The building could be adapted to accommodate the type of event by bringing in more seating and staging until it could hold nearly 18,000 for some speaking events. (Courtesy of NCSU Libraries' Special Collections.)

Buckminster Fuller receives an honorary degree on June 6, 1954. (Courtesy of NCSU Libraries' Special Collections.)

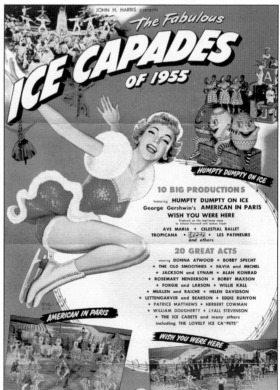

The Ice Capades were a popular draw in Reynolds, and typically brought in a full house. (Courtesy of NCSU Libraries' Special Collections.)

The Harlem Globetrotters made many visits to Reynolds over the years. (Courtesy of NCSU Libraries' Special Collections.)

The Arnold Air Society and Angel Flight sponsored an evening with comedian Bob Hope in Reynolds Coliseum.

The Metropolitan Opera performs *Madame Butterfly* in Reynolds Coliseum as a part of the Friends of the College series. (Courtesy of NCSU Libraries' Special Collections.)

Leonard Bernstein (seated) signs an autograph for Nell Joslin, age 7, in April 1961. Standing in the back (from left to right) are Ben Williams, head of the N.C. Museum of Art, and William Joslin, president of the Friends of the College. (Courtesy of NCSU Libraries' Special Collections.)

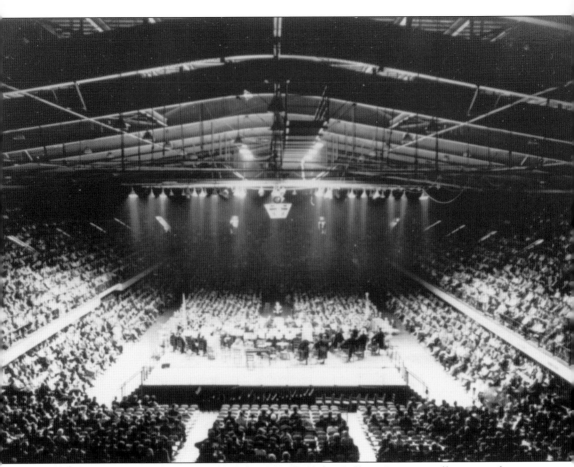

Henry Bowers, longtime director of the Friends of the College Series, recalls one performance in particular. "In October, 1962, during the time of the Cuban missile crisis, the Leningrad Philharmonic Orchestra was scheduled to perform in Reynolds. They had been touring up and down the East coast, and had been receiving a very cold reception at those concerts. While they were here in the US, President Kennedy ordered the Russians to remove the missiles from Cuba, and the whole world was very tense. The very day the Leningrad Philharmonic was to play here in Reynolds, Khruschev agreed to remove the missiles. There was a tremendous reception for the orchestra and great enthusiasm for their concert. I don't know who was more relieved—them or us." (Courtesy of NCSU Libraries' Special Collections.)

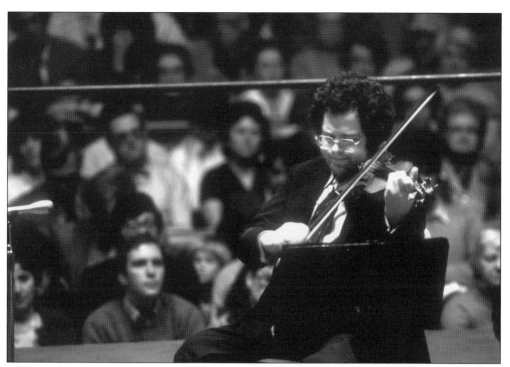

The reigning virtuoso of the violin, Itzhak Perlman, performs in Reynolds Coliseum. (Courtesy of Roger Winstead.)

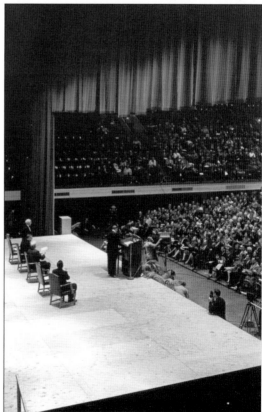

Adelai Stevenson speaks to the crowd on November 6, 1956. (Courtesy of NCSU Libraries' Special Collections.)

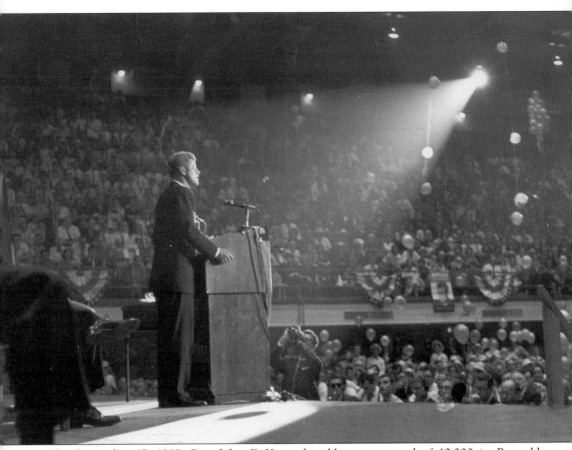

On September 17, 1960, Sen. John F. Kennedy addresses a crowd of 10,000 in Reynolds at the end of a two-day barnstorming tour of North Carolina. (Courtesy of NCSU Libraries' Special Collections.)

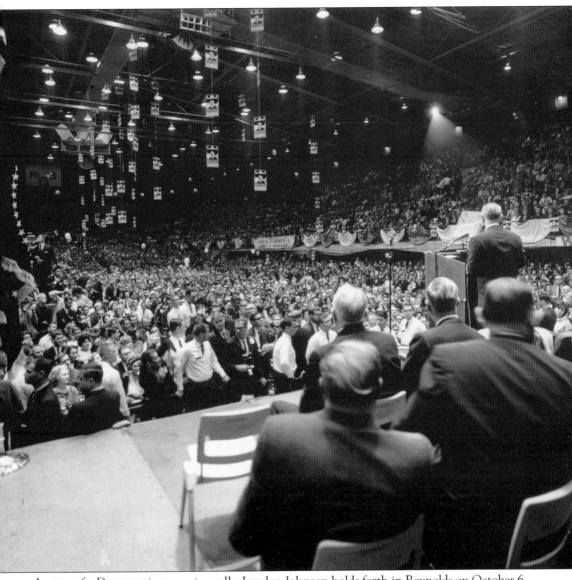

As part of a Democratic campaign rally, Lyndon Johnson holds forth in Reynolds on October 6, 1964. (Courtesy of NCSU Libraries' Special Collections.)

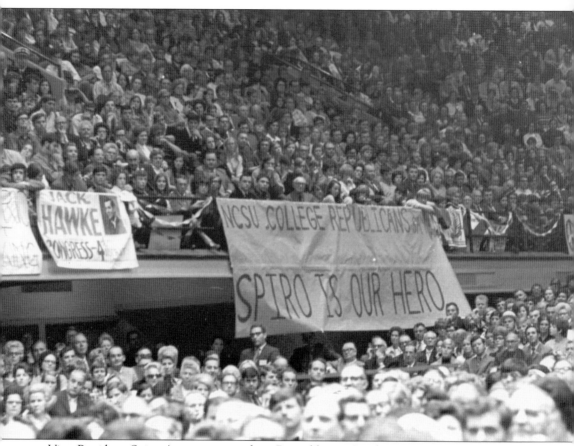

Vice President Spiro Agnew appeared in Reynolds on October 26, 1970 for a Republican campaign rally. (Courtesy of NCSU Libraries' Special Collections.)

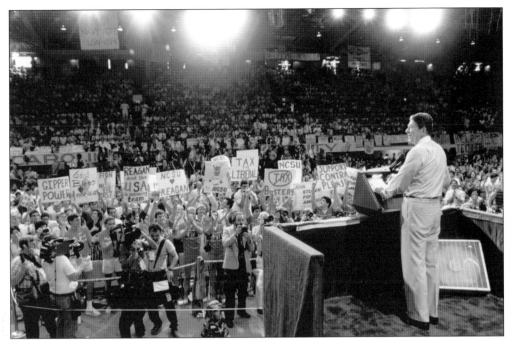

Without air conditioning, Reynolds becomes sauna-like in hot weather. On September 5, 1985, Ronald Reagan addresses a full house under steamy conditions in Reynolds Coliseum. (White House photo.)

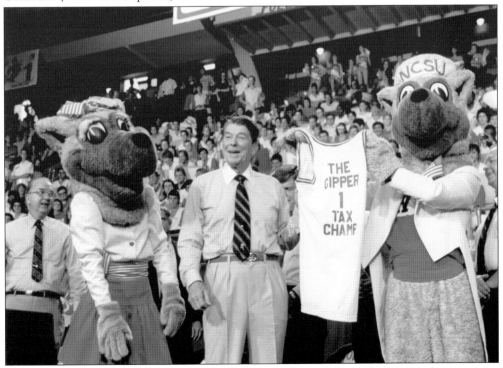

Ronald Reagan receives a "Gipper" NCSU basketball jersey from the Wolfpack mascots as Sen. Jesse Helms looks on. (White House Photo.)

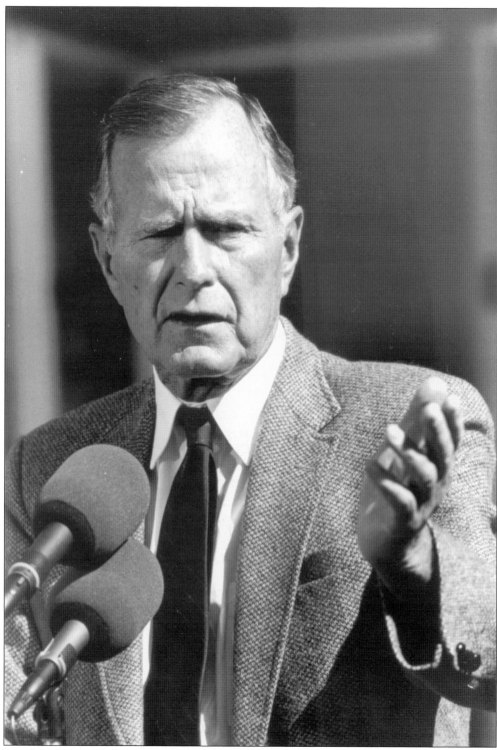

President George Bush Sr. visited Reynolds on February 2, 1990. (Courtesy of NCSU Libraries'
Special Collections.)

This 1952 hockey program is evidence of Reynolds short-lived skating rink. (Courtesy of NCSU Libraries' Special Collections.)

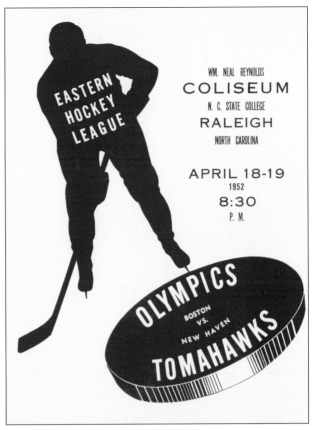

This photo shows the hockey floor as it appeared in the 1950s. (Courtesy of NCSU Libraries' Special Collections.)

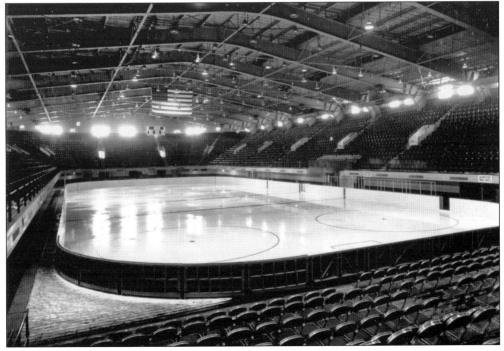

This photo pictures Kenny Rogers in concert. In the 1980s, Reynolds would host such popular acts as Hank Williams Jr.; Eddie Murphy; Aerosmith; Rush; Reba McEntire; Earth, Wind, and Fire; Alabama; AC/DC; and the Smothers Brothers. (Courtesy of Roger Winstead.)

Def Leppard lead singer Joe Elliott is on stage in Reynolds. (Courtesy of NCSU Libraries' Special Collections.)

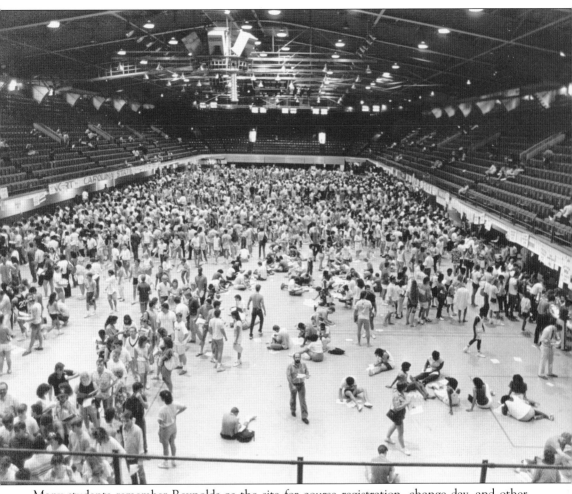

Many students remember Reynolds as the site for course registration, change day, and other administrative events with long lines. (Courtesy of NCSU Libraries' Special Collections.)

The lobby remains as impressive today as it was when it opened. The days of white-gloved opera patrons have passed Reynolds by, but the building's functionality has not. The red marble lobby walls, quarried from Tennessee, have visible remnants of fossils. The viewing of ammonites and cephalopods has been assigned as homework for geology students over the years.

Six

CHAMPIONSHIPS AND BEYOND

In 1973, Reynolds Coliseum got a facelift. Over the summer, officials at NC State appropriated $370,000 for renovation of the building. The seats were painted red and white, replacing the dull green that had been there since 1949. Some of the bleachers were repaired or replaced, a four-sided message scoreboard was added over the existing scoreboard, and a new roof was added. Air conditioning was planned for but never installed. (Courtesy of NCSU Libraries' Special Collections.)

The most noticeable change was the installation of a new resilient playing surface made of synthetic urethane and called Proturf. Beige in color with red and white borders, the new floor looked particularly impressive on television broadcasts. (Courtesy of Burnie Batchelor.)

The most important addition to Reynolds Coliseum was orchestrated by Norm Sloan. One of Case's original Hoosier Hotshots, Sloan and his 1974 team hung the first national championship banner in Reynolds. This photo shows Sloan (center) coaching in the 1967–1968 season. (Courtesy of NCSU Libraries' Special Collections.)

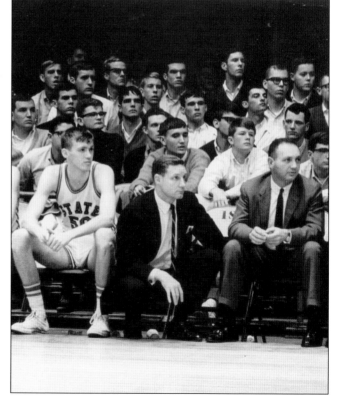

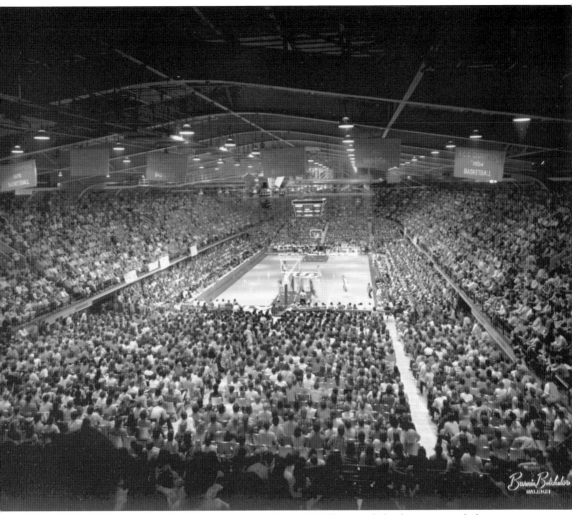

The 1973–1974 team started out the season with an 84-66 loss to defending national champion UCLA. The Wolfpack proceeded to win every game up to the championship game of the ACC tournament. In order to go on to the NCAA tournament they would have to beat Maryland, ranked fourth in the nation, in the championship. Many people remember this encounter as the best college basketball game they have ever seen. Monty Towe sank two free throws to seal a 103-100 win, and NC State advanced to the NCAA tournament. (Courtesy of Burnie Batchelor.)

One of the most memorable (and frightening) moments in Reynolds occurred against Pittsburgh in the 1974 NCAA regional. David Thompson leaped to block a shot, caught his foot on a teammate's shoulder, and crashed to the floor headfirst. Recalls assistant athletic director Frank Weedon, "I thought he was dead. Blood came out of one ear. There was total silence, like you had suddenly turned off a blaring radio." Thompson was placed on a stretcher (along with NC State's chances for an NCAA championship, most fans assumed) and was rushed to the hospital. The game continued in Reynolds, but all thoughts were on Thompson. (Courtesy of *The Raleigh News and Observer.*)

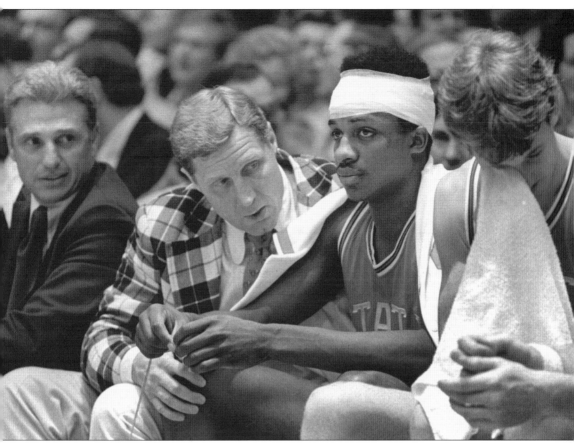

According to PA announcer C.A. Dillon, "At half time it was like a funeral in there. Then the athletic director came over and said to me, 'I have some good news, would you like to make an announcement?' Of course I milked it for everything it was worth. 'We have received word from Rex Hospital on the condition of David Thompson.' Then it got as quiet as I have ever heard it be in that old building, and I said, 'He's going to be OK.' Then it was deafening. I didn't think anything could be that loud." Midway through the second half, David Thompson walked through the players' tunnel and on to the perimeter of the playing floor and the crowd roared. The players ran off the floor and surrounded him. The large white bandage wrapped around his head covering the 15 stitches gleamed like a halo. The game was stopped until order was restored in Reynolds. Pitt had no chance at that point, and NC State went on to win that game and subsequently the 1974 NCAA national championship. (Courtesy of *The Raleigh News and Observer*.)

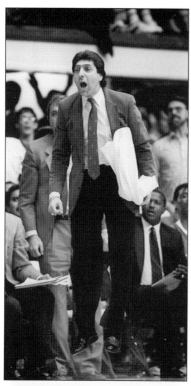

In his autobiography, Jim Valvano remembered: "Practicing every day in Reynolds Coliseum on the Raleigh campus, it didn't take long to realize I was no longer in the HaveNot mode . . . I would stand in the Coliseum with all those ACC and Dixie Classic banners hanging from the rafters and I would practically shake. Or I would walk around our offices in the Everett Case Athletic Center with the old NC State coach's picture staring down, and I swear Case's eyes would follow me wherever I walked." (Courtesy of Roger Winstead.)

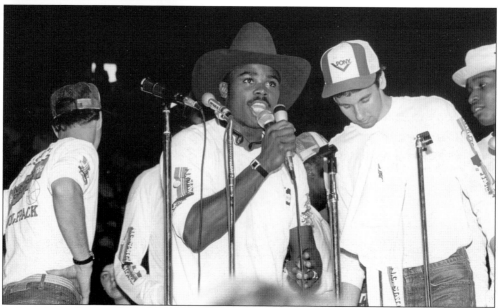

Sydney Lowe (pictured) and "Destiny's Team," as the press came to call the 1983 Wolfpack, hung the second national championship banner in Reynolds. In the NCAA championship game against Houston, guard Dereck Whittenberg flung a last-second desperation shot from 30 feet out and missed everything—except the hands of Lorenzo Charles. He dunked the air ball through the basket as time expired to give the Pack a 54-52 win in Albuquerque and capped one of the most improbable championship runs by any team. (*Agromeck* photo.)

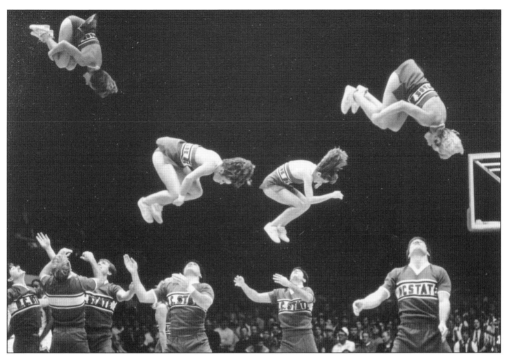

NC State Cheerleaders were a proud tradition in Reynolds. To date, the squad has won four national championships. (*Agromeck* photo.)

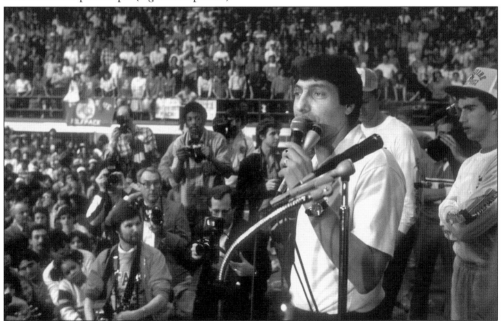

Reynolds Coliseum was the site of many celebrations through the years, but none were more joyous than the pep rally that awaited the Wolfpack upon their return to Raleigh. Exhausted from the journey and suffering from the flu, Jim Valvano spoke briefly to the crowd. "What I really want to say, is that it was great to win the national championship. But the proudest and happiest moment of my life is as I stand before you here now." (Courtesy of Roger Winstead.)

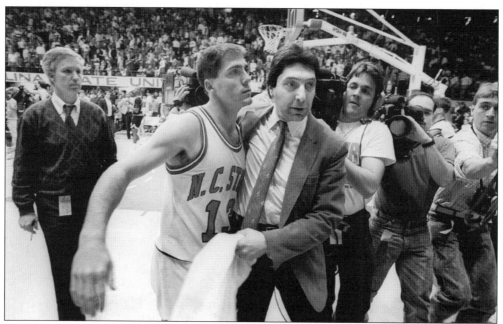

In this 1990 photo, Valvano celebrates his last game in Reynolds. Nearly three years later, the capacity crowd that arrived in Reynolds before the conclusion of the Duke-NC State game on February 21, 1993, were there to honor the former coach and celebrate the 10-year anniversary of his team's miraculous run for the NCAA title. Stricken with cancer and battling the effects of chemotherapy, the once high-energy coach had to be helped onto the stage. He talked about believing in miracles, believing in love, and never giving up. "Nobody had more fun than I did for the 10 years I was fortunate enough to stand in that corner [pointing to the Wolfpack bench] before every game." Sixty-five days later, Jim Valvano passed away. (Courtesy of Roger Winstead.)

Broadcaster Dick Vitale takes a few warm-up shots in Reynolds before an ACC match up against Maryland. (Courtesy of NCSU Libraries' Special Collections.)

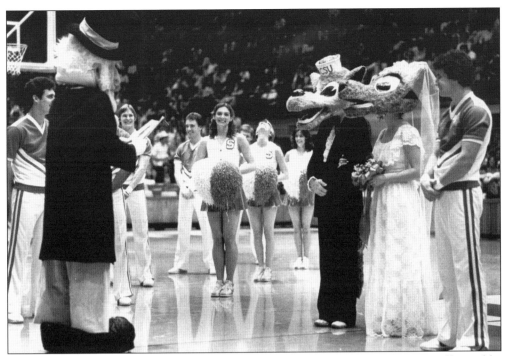

Reynolds proved to be the true all-purpose facility. This 1981 wedding ceremony, officiated by the Wake Forest Deacon, united the Wolfpack mascots at center court in Reynolds. (Courtesy of NCSU Libraries' Special Collections.)

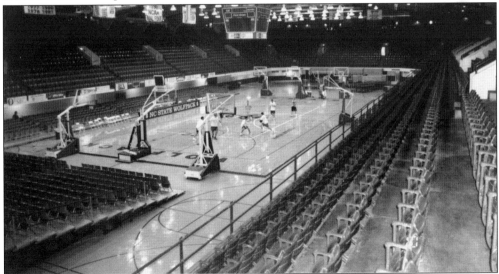

When Les Robinson took over as coach in 1990, one of his first acts was to have the synthetic floor in Reynolds removed. Synthetic surfaces had become unpopular with players and proved to result in more injuries. Robinson had the original wooden floor brought up from its storage site in the basement of Reynolds. Workers who refinished the floor were surprised by the excellent condition of the old court, commenting that it was superior to floors they were installing in new gymnasiums today. The Wolfpack must have found the court appealing as well as they proceeded to win their first 11 games on the hardwood.

121

Herb Sendeck took over as head coach of the Wolfpack in 1996. When hired, Sendeck remarked that watching games in Reynolds on television left an impression on him, even though it seemed "a little dark." Sendeck would get the chance to turn off the lights on men's basketball in Reynolds for good as the building's last coach. (Courtesy of Roger Winstead.)

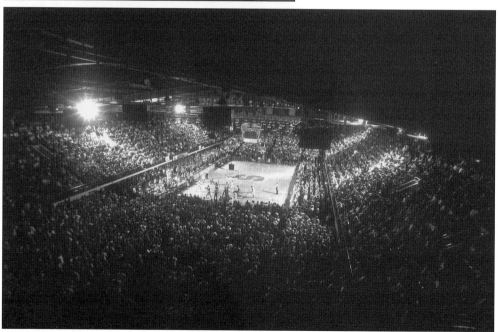

This photo was taken at the last scheduled home game in Reynolds Coliseum on February 24, 1999. The Wolfpack defeated Florida State 71-63. The actual last game was a second-round NIT loss to Princeton on March 15, 1999. (Courtesy of Roger Winstead.)

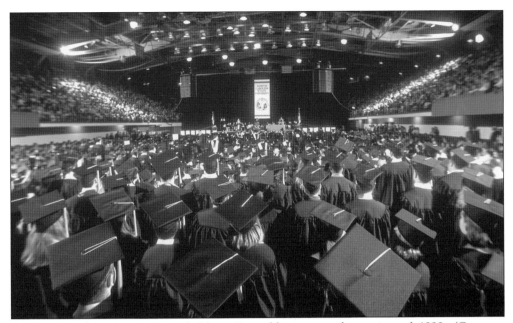

The last graduation ceremony held in Reynolds was in the spring of 1999. (Courtesy of Roger Winstead.)

What about the future of Reynolds? The old coliseum, once the biggest and brightest venue in the Southeast, is showing its age. The windows are all painted black and sunlight doesn't permeate into the playing area. By modern standards, Reynolds is not large enough to compete with those places that seat twice as many people and are more flexible. During events, the narrow hallways are crowded, there is no air conditioning, and parking is impossible. (Courtesy of Roger Winstead.)

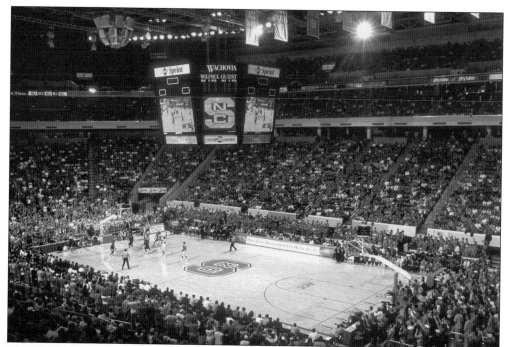

The Wolfpack now plays its home games in the $158 million Entertainment and Sports Arena. The new facility can seat 20,000 for basketball. Just as Reynolds had its share of extras when it opened in 1949, the ESA has 61 luxury suites, 580 television monitors, and a 500-seat restaurant. (Courtesy of Roger Winstead.)

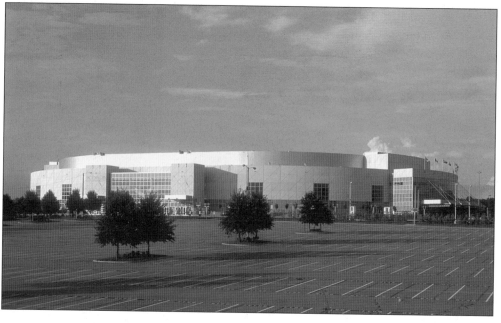

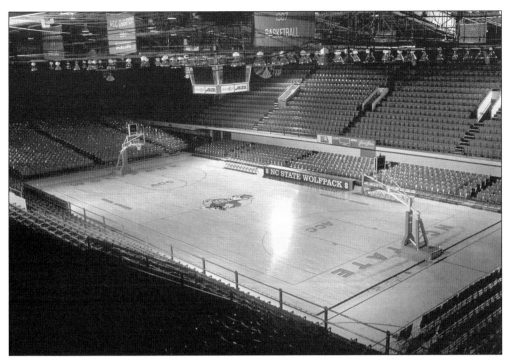

Reynolds Coliseum now serves as the home venue for Wolfpack Women's basketball. (Courtesy of Roger Winstead.)

The Wolfpack Women's basketball coach is Kay Yow (back row, right), shown here with her first team in 1976. (Courtesy of NCSU Libraries' Special Collections.)

Kay Yow has won 269 games in Reynolds Coliseum through the 2001–2002 season, making her the winningest coach in Reynolds. Everett Case is second with 211. (Courtesy of Roger Winstead.)

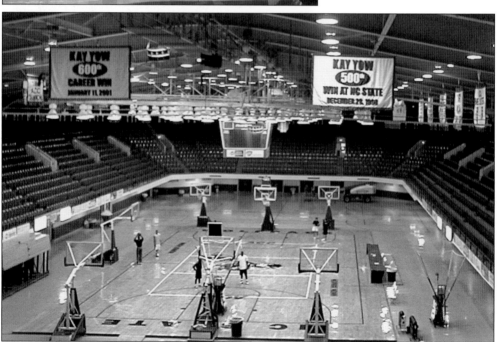

Banners hanging in Reynolds acknowledge some of Yow's achievements, including her 600th win on January 11, 2001. Yow is only the fifth women's basketball coach to reach this milestone. During her tenure at NC State, Yow has coached 10 All-American players and coached the Olympic team to a gold medal in 1988.

Not all records set in Reynolds Coliseum are basketball-related. Ken Blackburn set the world record for paper airplane time aloft in Reynolds on November 29, 1983, with a flight time of 16.89 seconds. Blackburn, author of *World Record Paper Airplane Book*, is pictured in this photo breaking his own record at 27.6 seconds in 1998 in the Georgia Dome in Atlanta, Georgia. (Courtesy of Peloton Sports.)

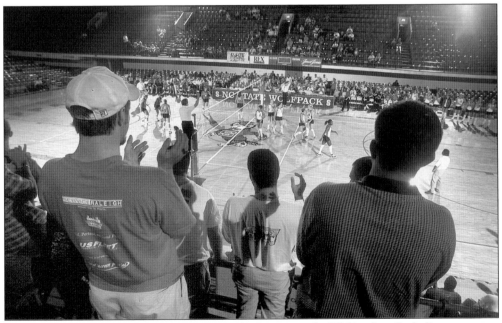

Other sports continue to use Reynolds. It is the home site for Wolfpack volleyball, gymnastics, and wrestling. (Courtesy of Roger Winstead.)

These ROTC students gather outside the front entrance of Reynolds Coliseum like they have for half a century. The first floor of Reynolds Coliseum continues to house offices and classrooms for Navy, Army, and Air Force ROTC programs.

Nowadays people walk past the old building with little awareness of the impact Reynolds Coliseum had on the state of North Carolina. But for some, if they look carefully, they might just see the image of Everett Case, somewhere in the shadows, trying to think of just one more way to make Reynolds Coliseum a showplace.